THE INDUSTRIAL REVOLUTION IN THE TEES VALLEY

Colin Wilkinson

AMBERLEY

First published 2018

Amberley Publishing
The Hill, Stroud
Gloucestershire, GL5 4EP

www.amberleybooks.com

British Library Cataloguing in Publication Data.
A catalogue record for this book is available from the British Library.

ISBN 978 1 4456 8247 1 (print)
ISBN 978 1 4456 8248 8 (ebook)

Typesetting and Origination by Amberley Publishing.
Printed in Great Britain.

Contents

Introduction

In the early decades of the eighteenth century Daniel Defoe published his *Tour Through the Whole Island of Great Britain* and included his impression of some of the towns along the River Tees. At Barnard Castle he found it 'an ancient town and pretty well built, but not large'; Darlington was described as 'a post town, nothing remarkable but dirt and a high bridge over little or no water'. Then there were 'two good towns (viz) Stockton and Yarm, towns of no great note'. The tour did not extend as far as Middleton in Teesdale, where he could have commented on the ancient lead mines, nor did Defoe see the need to visit the little hamlet of Middlesbrough at the other end of the River Tees. A return to the area in the middle of the next century would reveal momentous changes, which had brought factories, mills, railways, engineering works, iron foundries, ports and new towns.

This new world was introduced to an ageing emigrant returning, in the nineteenth century, from America to his native village of Kilton in East Cleveland. As he journeyed into the neighbourhood of his youth he passed on the way 'Middlesbrough with its 40,000, Eston Branch with its blazing furnaces, a new Saltburn by the Sea, all of which he had never seen'. Our traveller commented on the emergence of Middlesbrough but, as we will see, the other towns along the Tees also attracted people to work in the developing industries.

Throughout the country there was a growing population ready to take up the employment that was on offer. At the start of the eighteenth century the English population was around 5 million; by 1861 it was close to 19 million. This growth brought concerns about the ability of the farming community to produce enough food. Thomas Malthus was vociferous in highlighting the potential for disaster and in 1798 he published *An Essay on the Principles of Population Growth*, warning that production of food could not be maintained at the same rate as the population was growing. Fortunately there was no catastrophe and developments in farming kept pace; land was cleared for agriculture, crop rotation was improved and cereal yield increased, while advances were made in the selective breeding of livestock. Locally, Teeswater sheep were bred to be hardy and to produce meat and long fibres of wool, and the Colling brothers, farming near Darlington, bred Durham Shorthorn cattle to mature quickly and provide beef and fat. Economies of scale encouraged large farms. Our returning emigrant saw this; as he came to the village of his youth he found that 'some twenty cottages and farmsteads that once graced the little town had all disappeared ... I remember ten farmers, occupants of some seven hundred acres, and now it's absorbed into one large farm, by laying field on field, and adding farm to farm'.

While agriculture responded to the demands of a growing population, the focus of this book is the Industrial Revolution. Industrialisation did not suddenly appear; the conditions needed gradually emerged until, during the eighteenth century, the economy moved to a new direction. Government polices protected domestic industry and consequently stimulated industrial growth. Customs duties levied on imported manufactured goods encouraged home industries; for example, duties on French linen, glass, spirits (gin was to replace brandy) and paper were high. Where raw materials had to be imported, the level of duty was kept low. Textiles manufacturers were protected against foreign competition with a ban on the export of wool fleeces. When a threat to the home industry was seen from a growing fashion to buy Indian cotton clothing action was taken and the Calico Act of 1721 banned the wearing of imported cotton clothes; this encouraged production in England and the cotton industry emerged. This level of control over the economy by the Government did not continue and during the nineteenth century it became accepted that the influence of the Government needed to be reduced and barriers to trade removed. The country's manufacturing base was robust enough to take advantage of export markets by allowing free trade. However, the loss of revenue from tariffs meant that the Government had to find a new source of revenue – income tax.

While entrepreneurs responded to the Government's policies, industrialisation did not flow at an even pace across the country, and some regions started to emerge as manufacturing areas ahead of others; for example, the West Midlands became a centre of iron making and pottery manufacture, while in Lancashire the opportunity to produce cotton textiles was grasped. Here inventors were at work looking to improve the process and they produced large spinning machines that, unlike the traditional spinning wheel, could no longer be used in homes and needed to have water or steam to provide the power to drive them.

The towns along the Tees did not play a significant part in the early years of the Industrial Revolution, although during the eighteenth century the London Lead Co. (LLC) arrived in Teesdale and started to overhaul the lead mining industry. Despite a hesitant start, the entrepreneurs, inventors and innovators in the towns along the Tees started to transform the area into a significant industrial force.

The railways are a dramatic part of the story and provide a striking application of the steam engine. Throughout this book there are references to steam power and the development of the steam engine must rank among the most important breakthroughs of the Industrial Revolution. It was a new form of power to supplement those that had so far been available; namely, water, wind, animal and manpower. Early engines introduced by Thomas Newcomen were large, inefficient machines and, because they needed so much fuel, were mainly used to pump water from coal mines where fuel was readily available. Advances to the steam engine were made by James Watt, who improved its efficiency and engineered a method of changing the back and forward motion of the engine's piston to a rotary motion by a system of gearing known as sun and planet, thus extending the application of steam power. Then Richard Trevithick showed that steam could be safely used under high pressure, which allowed the size of the engines to be reduced. In 1801 he built the *Puffing Devil* – a steam-powered road vehicle heralding the application of the engine to transport.

The pioneering railway from the South Durham coalfield to Stockton formed a major part of the transport revolution and features in the first chapter before the experiences of the towns and villages along the Tees are reviewed.

When was the Industrial Revolution completed? It can be suggested that it has never ended, with a constant development in technology and manufacturing processes still being experienced. This book takes the story to the early years of the 1870s, when the move from an economy built on agriculture and largely domestic-based industry had been achieved and the pattern of the new order for the future development of the economy was established.

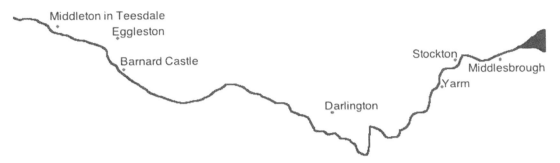

The River Tees and towns along its course.

Roads, Canals and the Railway

Travelling could be torturous. In 1764 a stagecoach ran from Newcastle to York and the journey took three days with overnight stops at Darlington and Thirsk. Movement of goods was equally demanding and often coastal shipping was faster than labouring along the roads. However, the inland transport system did start to improve when Turnpike Trusts were formed and they took over the repair and maintenance of roads, reversing the system implemented during the reign of Queen Mary (1553–1558) whereby each parish was made responsible for the upkeep of their roads. This had not

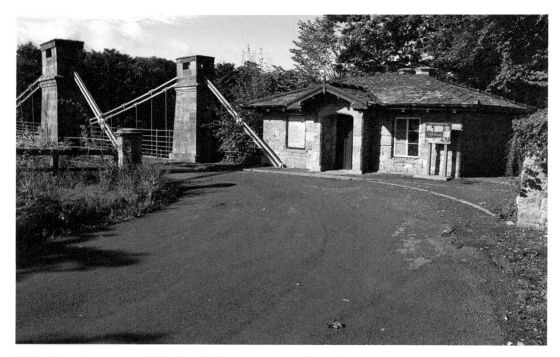

Toll collector's cottage at Whorlton Bridge, near Barnard Castle.

been successful, with many parishes finding it difficult to fund repairs, particularly those who had major routes passing through. Turnpike roads transferred the cost from local inhabitants to those who used the roads and toll collectors waited at gates along the road to collect the fees.

Wagons attracted the highest charges and the toll was dependant on the width of wheels. Wagons with narrow wheels were responsible for more damage and attracted greater tolls than those with wide wheels, which spread the load. For example on the Durham–Boroughbridge road the charge in 1792 for a wagon pulled by four horses with wheels 9 inches wide was 2/- (10p), while those with wheels less than six inches wide had to pay 4/- (20p).

Charles Dickens described the experiences of a lone toll collector: 'When the man had gone to bed and then came knocking at the door until answered … and presently came down nightcapped and shivering to throw the gate wide open and wish all wagons off the road except by day.' The toll gates were often leased and the toll man would have to respond to such demands as his livelihood depended on collecting tolls. It became a regular practice to hold an auction and sell the use of the toll gate to the highest bidder, who would collect the tolls, pay the fee settled on and keep any surplus to provide for himself and his family. The rights to collect the tolls on the Eggleston Coal Road were advertised for auction in October 1855. The Eggleston Gate fetched £315. This was no doubt the busiest gate on the road as others attracted lower bids; at Stotley, for example, the gate brought £180, while the West Pits gate brought £282.

Darlington was on the Great North Road and the stretch between Boroughbridge and Durham was turnpiked in 1744. Stockton's port benefited from roads leading into the town; in 1747 the road from Durham to Stockton, which carried on to Yarm and Catterick, was turnpiked. The road from Stockton to Darlington and Barnard Castle was improved in the 1740s and a route across the Pennines to Lancaster was opened in 1751. The route into North Yorkshire was particularly important as it provided a connection from Richmond, from where lead from the Swaledale mines was collected to be taken to the ports at Yarm and Stockton.

Transporting coal from the mines in South Durham to the towns along the Tees Valley prompted the development of a number of roads. From West Auckland the coal roads, as they became known, ran to Darlington, Stockton and into North Yorkshire. A coal road also ran from West Auckland to Eggleston, no doubt to supply the nearby lead smelting works.

These roads did allow trade to increase but the towns along the Tees did not experience the great benefit that canals brought. There were considerable advantages to be had from canals, particularly to those operating coal mines, as was shown by the Bridgewater Canal in the North West. This canal, which was opened in 1761, was built by the Duke of Bridgewater to carry coal from his mines in Worsley to Manchester and the resulting reduction in the cost of transport halved the price of coal in the city. James Brindley was the engineer on the Bridgewater Canal and his services were soon demanded by canal promotors through the country as 'Canal Mania' struck and the major centres in the country were connected by waterways.

However, canals did not reach the Tees despite a number of schemes being proposed. North Yorkshire was the extent of their reach. Acts of Parliament were passed in 1767, allowing part of the Swale to be made navigable. The River Ure beyond Boroughbridge

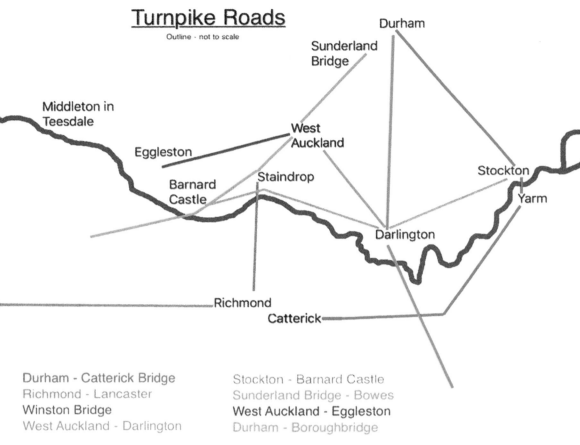

Turnpike Roads
Outline - not to scale

Durham

Sunderland Bridge

Middleton in Teesdale

West Auckland

Eggleston

Staindrop

Stockton

Barnard Castle

Yarm

Darlington

Richmond

Catterick

Durham - Catterick Bridge
Richmond - Lancaster
Winston Bridge
West Auckland - Darlington

Stockton - Barnard Castle
Sunderland Bridge - Bowes
West Auckland - Eggleston
Durham - Boroughbridge

Sume of the major turnpike routes around the Tees.

was also to support a canal, which was to be cut to Ripon, and work was authorised on the Cod Beck to allow boats to reach Thirsk. Not all succeeded; the Thirsk scheme was abandoned, as was some of the work on the Swale, with the costs rising beyond those planned and the money running out.

The opportunity that a canal presented was not lost on George Dixon, who operated a coal mine at Cockfield (a village south-west of Bishop Auckland), and in the 1760s he proposed carrying coal from his colliery by 'a small canal'. He looked to Lord Darlington, from whom he leased the mine, for finance but nothing was available and the scheme died. Dixon also had an idea to move coal by building 'a contrivance … for conveying coals by water, without boats', using an incline with water rushing down it and 'when a cart load of coals was put into it, they swam or were carried … into a reservoir at the lower end'.

Merchants and mine operators in the area were aware of the benefits that a canal could bring. In December 1767 a meeting was held in Darlington to promote a canal and money was raised to pay for a survey. James Brindley was engaged and, as he often did, delegated the work to his son-in-law, James Whitworth.

THE
REPORT

O F

Mefl. *Brindley* and *Whitworth*, Engineers,

C O N C E R N I N G

The PRACTIBILITY and EXPENCE

O F M A K I N G A

NAVIGABLE CANAL,

From *Stockton* by *Darlington* to *Winston*,
in the County of *Durham*.

W I T H

A PLAN of the COUNTRY,

River TEES, and of the intended CANAL.

S U R V E Y E D A N D M A D E

By Order of the COMMITTE of SUBSCRIBERS,

J U L Y 19, 1769.

Brindley and Whitworth's report on the canal from Winston to Stockton.

The route selected for the canal would start at Winston, move north towards Staindrop and then across the country to Cockerton, which at the time was a village outside Darlington. It would then go on to Darlington and finally to Stockton, with a total length of over 33 miles and forty-one locks. The survey included branches to Piercebridge, Croft and Yarm, giving access to the bridges across the river and the North Yorkshire market. The canal would not reach the collieries, with the proposed route keeping to the south of the coal field. A branch of the canal that would go

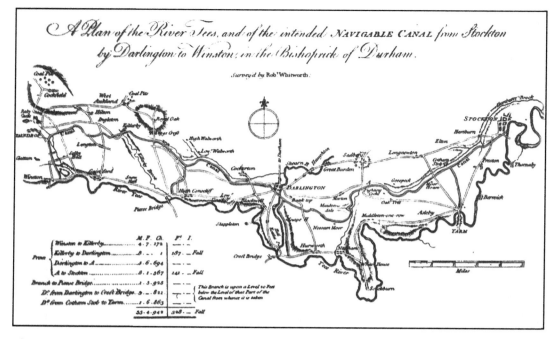

The proposed route of the canal to Stockton.

towards the pits and be connected by a waggonway from the collieries was also proposed; George Dixon rehearsed his idea of an incline, this time utilising barges to reach the main canal.

The canal project came to nothing; the main towns on the route – Darlington, Yarm and Stockton – were all fairly small at the time and did not have the population to provide the demand for coal needed to bring the revenue to provide a return on the estimated investment of £64,000. Here, as will be seen later with the railway enterprise, there was no thought of competing with the mines around Tyne and Wear, where there was a substantial business in shipping coal to London.

Later, there were two more proposals – one by an engineer and another by a surveyor, both no doubt looking to encourage schemes that would provide them with work. The first of these proposals came in 1796, when the people of Stockton were reminded of the advantages that a canal would bring in a report prepared by Mr A. R. Dodd, who 'wondered why this part of the kingdom should be so late in building a canal as no part of this island is so well calculated for their adoption from the immense tonnage to employ them, which includes stone, lime, lead and copper ores, coal and timber, to which may be added large imports annually of Levant, India and Baltic ports'. For the Tees he proposed a 'navigation from Stockton to Winston via Darlington and Staindrop', again not reaching into the coal mining district.

Nothing came of this but the idea of connecting to the canals in North Yorkshire had appeal, and a few years later, in 1800, George Atkinson, a surveyor from Richmond, came up with a grand proposal for a canal from Boroughbridge to Piercebridge with branches to Bedale and Richmond. There could also be a branch leaving the main canal

at Cowton and heading on to High Worsall, 'forming a junction with the Tees a little below the warehouses formerly used for depositing goods brought from the port of Stockton for the purpose of being taken to the west country by land carriage'. (The warehouses mentioned are those that had belonged to Thomas Pierse until he became bankrupt in 1779.) The cost of the scheme was £107,353, which included £64,649 for the main canal to Piercebridge and £22,629 for the 9-mile branch to High Worsall. Unfortunately, this high cost prohibited any support.

While no canal was built there was an improvement to the navigation of the Tees near Stockton in 1810 when a cut was made across a meandering section of the river that reduced the distance to the open sea by 2 miles. During the dinner held to celebrate the completion of the work, Leonard Raisbeck, a solicitor from Stockton who had been one of the driving forces behind the Tees cut, made the proposal that a canal or railway from the coal fields be considered.

The idea to build a railway was not totally revolutionary. Railways had been used for some time in Tyneside to take coal from the mines to the staithes, or loading stages, on the river at Newcastle. In the mid-eighteenth century, a description by a visitor noted that 'transportation from the mines to staithes is carried out by so called wagons. The wagons run on four solid wheels, either turned from a single piece of oak or cast in iron, although the later causes much wear on the roads which are built up to 8 or 10 miles from here. The roads are provided with wooden rails on both sides to ease the movement of the wheels.' The wagons were hauled by horses until steam locomotives began to be used along iron rails, and the experience gained by George Stephenson at Killingworth in developing the colliery engines would result in him becoming a leading figure in the story of the railways.

In Stockton progress to develop the scheme for a link to the collieries was slow, but by 1813 John Rennie, who had been appointed to prepare a report on the feasibility of a canal or railway, favoured a canal with an estimated cost of over £205,000 – considerably more than the cost that had been forecast in the 1760s. The scheme was not progressed with any great enthusiasm and by 1815 the expenditure was considered to be too high to risk any further action. The conditions did not seem right at this time, when economic activity had slowed after the end of the Napoleonic Wars and, locally, the failure of the bank of Mowbray & Hollingworth, which had branches in Darlington, Durham and Thirsk, as well as a London office, shattered confidence. There was little hope of raising money in those difficult times for such an ambitious project.

Then, in 1818, a Stockton trader, Christopher Tennant, who also had interests in lime kilns near Shildon, paid for a survey for a canal from the coal fields of South Durham south to Stockton. This was carried out by George Leather and his report outlined a route leaving the Tees below Portrack, passing north of Stillington to cross the River Skerne at Bradbury and continuing past Rushyford and Shildon to Evenwood Bridge. Over its 29 miles there would be fifty locks and seventy-six bridges. One justification for the scheme came from a coal owner, who made a calculation that of the coal deposits in the South, there were 153 million chaldrons (around 400 million tons) to be extracted – more than 'any human calculation needed'. Income would come from transporting coal, lime, lead and stone as well as other general merchandise and was forecast at £57,850 per year. The advantage that this could bring to Stockton was seen by many in the town and at a meeting to discuss the project it was agreed that a committee should

Stockton and Auckland intended
CANAL.

At a Meeting held at the Town-house in Stockton,

On *FRIDAY*, the *thirty-first Day of July*, 1818,

PURSUANT TO PUBLIC ADVERTISEMENT,

To consider of an Application to Parliament in the ensuing Session for making a Navigable
Canal from the River Gaunless at Evenwood Bridge, near West Auckland,
to the River Tees below Portrack, in the Parish of Stockton.

The Right Honourable The Earl of Strathmore in the Chair,

THE BUSINESS OF THE DAY HAVING BEEN OPENED, AND THE REPORT OF MR. LEATHER, THE
ENGINEER EMPLOYED BY MR. TENNANT TO SURVEY THE LINE OF COUNTRY
THROUGH WHICH THE CANAL IS PROPOSED TO PASS,
HAVING BEEN CONSIDERED,

The following Resolutions were approved of and agreed to : viz.

Moved by Cd. Sleigh, seconded by H. Vansittart, Esq.
1. THAT the making of a navigable Canal from the Gaunless to the Tees, as above mentioned, would be productive of great advantage to the Public, not only in supplying the Country upon the line of the Canal, but also the Eastern District of the County of Durham and Cleveland, and other parts of the North Riding of Yorkshire, with Coal, Lime, Stone, and Slate, and might moreover contribute by an export trade from the Port of Stockton towards supplying London and the Southern Parts of the Kingdom with Coals.

Moved by H. Vansittart, Esq. seconded by The Rev. J. Gilpin.
2. THAT an application be made to Parliament in the next Session for an Act to make the said Canal upon the Plan and Estimates which have been presented by Mr. Leather at this Meeting.

Moved by The Rev. J. Gilpin, seconded by W. Skinner, Esq.
3. THAT Subscription Books be opened immediately, and that the Subscribers to this undertaking have power to raise among themselves two hundred and six thousand pounds, or such other sum as may be necessary to complete the Canal, in shares of one hundred pounds each; and that the Subscribers may be incorporated by Parliament by the name and stile of "The Company of Proprietors of the Stockton and Auckland Canal," with all such powers as are usual and necessary in similar cases.

Moved by W. Skinner, Esq. seconded by M. Atkinson, Esq.
4. THAT the owners of lands through which the intended Canal shall pass may become Subscribers to the value of their lands which shall be taken for the purposes of the Act, the fractional parts beyond even hundreds of pounds being paid by the Company in money; and that a sufficient number of shares be reserved for such landowners, of which they shall signify their acceptance within one month after notice from the Solicitor or Clerk to the Subscribers.

Moved by M. Atkinson, Esq. seconded by Colonel Grey.
5. THAT the Subscriptions be paid into the hands of Messieurs Hutchinson, Place, and Co., or Messieurs Skinner, Holt, and Co., Bankers, Stockton, at such times and in such proportions as shall be determined upon at a General Meeting of Proprietors; but that no call shall exceed ten pounds per centum on each share, and that the calls shall be made at the distance of three months at the least from each other.

Moved by Col. Grey, seconded by J. Cartwright, Esq.
Moved by J. Cartwright, Esq. seconded by C. Tennant, Esq.
6. THAT Messieurs Hutchinson, Place, and Co., and Messieurs Skinner, Holt, and Co., and such Banking Houses in London as the Committee there shall appoint be receivers of the money to be subscribed and raised for the purposes of this undertaking, and that Subscription Books be immediately opened at their respective offices.

Moved by C. Tennant, Esq. seconded by The Rev. C. Anstey.
7. THAT George Leather, Esquire, be appointed Engineer to the Proprietors.

8. THAT Messieurs Clarke and Grey be appointed Solicitors and Clerks to the Proprietors, and also to the Committees.

Moved by The Rev. C. Anstey, seconded by Henry Hutchinson, Esq. Mayor of Stockton.
9. THAT the following gentlemen be requested to form themselves into a Committee in London for forwarding this undertaking, soliciting subscriptions, and conducting the business thereof there; and that any three of them be empowered to act, viz. Joshua Reeve, Edward Dowse, John Scott, —— Barclay, David Bevan, —— Curtis, George Wellank, Edward Robinson, William Grey, George Faith, Samuel Marshall, Henry Blanchard, William Wilkinson, John Blackett, James Stonehouse, Joseph Dowson, John Metcalfe, Richard Percival, Thomas Richardson, and Christopher Tennant, Esquires, with power for them to add to their number if they shall see proper.

A notice regarding the canal to Stockton via the 'northern route'. (Centre for Local
Studies, Darlington)

be formed to progress the scheme. Interestingly, Edward Pease and Jonathan Backhouse were involved. These two were Quaker businessmen from Darlington who went on to play a significant role in the development of the area. Edward and Jonathan must have gone back to Darlington to plan the rescue of the town, which was in danger of becoming isolated if this northern route was built.

The canal would require an Act of Parliament. Before this could be considered there was a requirement that at least 80 per cent of the funding had been raised; however, the subscriptions only reached £34,500 – nowhere near 80 per cent of the estimated cost of £205,283 – and the canal scheme was abandoned. The idea was not forgotten and in April 1819 a railway was proposed along the northern route. By then the businessmen in Darlington and Yarm had been busy and a Bill was ready for presentation to Parliament authorising a railway from the coal fields that passed Darlington and Yarm on the way to Stockton. There was then little point in competing in what was such a radical and risky scheme and the northern project was shelved, although, as will be seen, it was not forgotten and was to cause considerable tension in the future.

The businessmen of Darlington and Yarm had be spurred into action when they saw that the initiative by the people of Stockton to build a canal could have catastrophic consequences for their towns. At meeting in Darlington town hall it was agreed that a 'rail or tram road from the River Tees to the collieries and the interior of the county [would] essentially promote, as well as agriculture, the mining and commercial interest of the district'. George Overton, an engineer from Wales, was employed to prepare a report and his proposal detailed a rail line to the Etherley colliery with branches to other collieries and to Yarm, Piercebridge and Croft. The project was accepted and subscribers were sought to buy shares of £100 to fund the £124,000 estimated cost, much less than that estimated for the canal a few years earlier. Additionally, unlike some of the earlier proposals, the railway would reach into the coal field. Local and London banks were used to collect the funding. Raising the money was difficult but Quaker family connections rescued the scheme; the Backhouse and Pease families invested and they gathered financial support from around the country, including from the Gurneys of Norwich, who had considerable banking interests.

The Bill to authorise the railway was presented to Parliament in 1819 and was defeated; the promotors could not overcome the objections, particularly those of Lord Darlington, who was angered at the prospect of the line cutting through his land and disturbing the fox hunting. Before the next attempt to gain approval was made the route was changed to avoid Lord Darlington's land, but this revised scheme failed, the presentation unfortunately coinciding with Parliament being dissolved on the death of King George III. This delay allowed the route to be surveyed again and another modification was agreed at a meeting held at the George and Dragon in Yarm, which reduced the length of the line with a consequent reduction in cost. The third reading of the Bill was successful and the Act of Parliament formed the Stockton & Darlington Railway Company (S&DR).

The Act that received Royal Assent contained some interesting clauses. For example, one section prohibited any person to 'ride, lead or drive … any horse, mule or ass … or any cow, cattle, sheep, swine or any other beast or animal' along the railway. Presumably there was a fear that the railway would be seen as a convenient

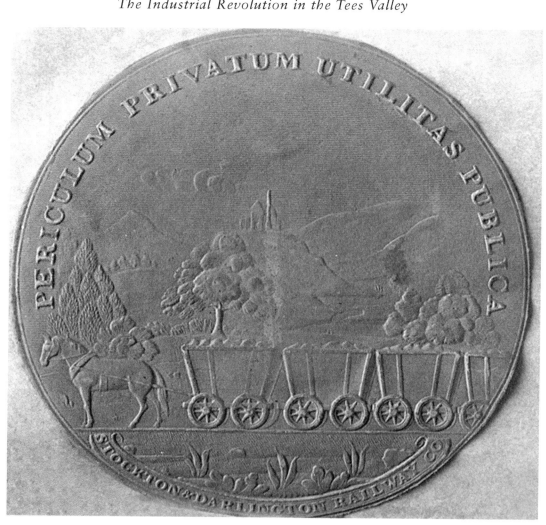

The Stockton & Darlington Railway seal. (Beamish Collection)

and well-constructed track that could be used by all. The Act also specified two rates to be charged for carrying coal – one at 4*d* per mile per ton and a lower rate of ½*d* to be charged for coal which was to be exported. The lower rate had been forced on the company by mining interests to the north around the Wear and Tyne who wanted to prevent competition from the port of Stockton in the shipping of coal to London. As will be seen, this low rate had the opposite effect and soon coal was being loaded onto ships berthed at Stockton.

As the Bill was progressing through Parliament, George Stephenson and his work in constructing locomotives at Killingworth came to the attention of the promoters. Edward Pease recognised that Stephenson would be ideal as the engineer for the line, and when Pease visited the colliery to see Stephenson's engines he was so impressed that he pushed

for their use on the railway rather than using horses to pull wagons. He went so far as to comment, 'Don't be surprised if I should tell thee there seems to us after careful examination no difficulty in laying rail road from London to Edinburgh.' Stephenson was appointed the engineer for the railway, supported by two engineers – John Dixon, who was the grandson of George Dixon, who had been active in the mid-eighteenth century with proposals for canals, and Thomas Storey.

The line was opened on 27 September 1825, with the locomotive on the opening day reaching the heady speed of 12 mph. The route from the colliery at Witton Park, 2 miles north of West Auckland, was described in a newspaper article in 1827:

> From the collieries … the coal wagons are conveyed by horses to the foot of Etherley Ridge. Here the horses are detached and wagons drawn up the north side of the ascent by means of a steam engine which is fixed at the top and draws a rope that reaches to the foot of the hill where it is attached to the wagons and raises them. At the top the wagons are attached to another rope … down this slope the wagons descend by their

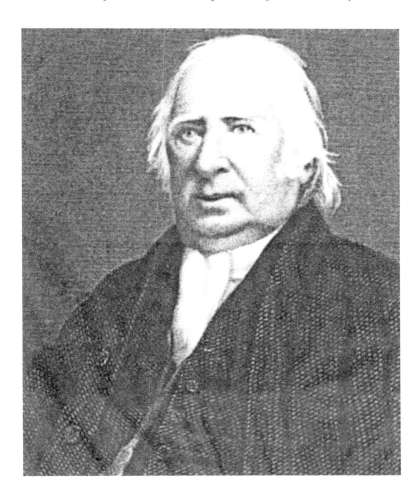

Edward Pease (1767–1858).

own gravity. A new set of horses draws the wagons about a mile and a quarter and to the foot of Brussleton Hill up which the wagons are again conveyed by a long rope and a fixed steam engine. From the bottom of Brusselton Hill, no further interruption occurs in the line and the wagons can thence be drawn all the way to Stockton … by locomotive.

Killingworth Colliery
April 28th 1821

Edw: Pease Esq.

Sir. I have been favored with your Letter of th 20 Inst & I am glad to learn that the Bill has passed for the Darlington Rail Way.

I am much obliged by the favorable sentiments you express towards me : & shall be happy if I can be of service in carrying into execution your plans —

From the nature of my engagements here and in the neighbourhood, I could not devote the whole of my time to your Rail Way, but I am willing to undertake to survey & mark out the best line of Way within the limits prescribed by the Act of Parliament and also, to assist the Committee with plans & estimates. and in letting to the different Contractors such work as they might judge it adviseable to do by Contract and also to superintend the execution of the Work —

And I am induced to recommend the whole being

done by Contract under the superintendance of competent persons appointed by the Committee —

Were I to contract for the whole line of Road it would be necessary for me to do so at an advanced price upon the Sub. Contractors, and it would also be necessary for the Committee to have some person to superintend my undertaking. This would be attended with an extra expence, and the Committee would derive no advantage to compensate for it —

If you wish it: I will wait upon you at Darlington at an early opportunity when I can enter into more particulars as to remuneration &c. &c. —

I remain yours
respectfully
Geo Stephenson

Above and opposite: Letter from George Stephenson to Edward Pease regarding his role in surveying the Stockton & Darlington Railway. (Reproduced by permission of Durham County Record Office D/PS/3/4)

As this was such a pioneering project there was no established way of operating a public railway and the practices that were used on the roads and canals were transferred to the railway. The line could be used by anybody with suitable wagons and a horse to pull them; alternatively, the company's wagons and locomotives could be hired. There was no expectation, during the planning process, that the railway would provide passenger services, but a coach called *Experiment* was soon carrying people from Darlington to Stockton. The influence of road transport was seen again and services began to be operated using coaches that had been converted to run on the rails. A report in 1827 noted that 'the vehicles are bodies of old six inside coaches placed upon new and lower wheels fitted for the rails'. Even coaches built in later years still reflected the coaching days. Coach No. 31, for example, was built for the Stockton & Darlington Railway in 1846 by Horner & Wilkinson in their factory in Commercial Street, Darlington. The carriage was decorated in the company's maroon colours with banding that still hinted at the shape of the road-going coaches.

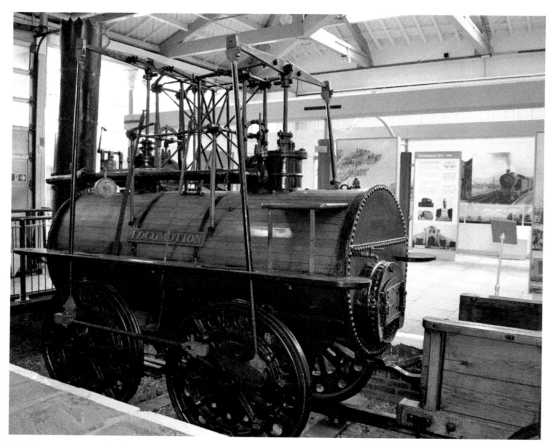

The *Locomotion*, the first steam engine used on the Stockton & Darlington Railway. (Darlington Head of Steam Rail Museum)

Brusselton Incline.

The engine room at Brusselton Incline.

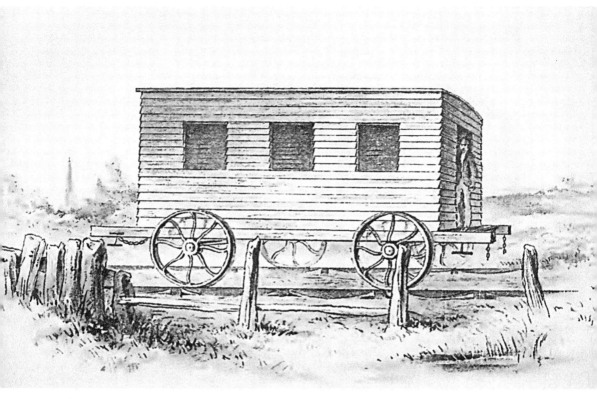

The first passenger coach was called the *Experiment* and it may have looked like this drawing from the nineteenth century.

The line was single track with passing loops. Although there were supposed to be rules setting out who had priority, they were flouted and consequently incidents of 'rail rage' were seen. Wagons drawn by locomotives were to have the right of way but this was not always observed and locomotives would have to crawl behind horse-drawn vehicles, and would even have to wait behind wagons while the wagoner visited the local pub.

The railway was a success and was soon used far beyond the expected levels; in 1828 some 46,000 tons of coal were moved, and by 1830 this had increased to 152,000 tons. The line needed to be doubled and the mixture of horse and locomotive haulage ended. The 1830s saw this happen, starting with the second track in 1831, and in 1833 horses were excluded from the main part of the line. However, the branches serving collieries continued with horse-drawn wagons for some time.

Inevitably the railway operators faced some teething problems, including trouble with wagons that had no suspension damaging the rails and locomotives that needed repair and modification. Fortunately, Timothy Hackworth, the resident engineer, was able to resolve problems, improving wagon design and modifying the unreliable locomotives at his Soho works in Shildon. His engine, the *Royal George*, which was built in 1827,

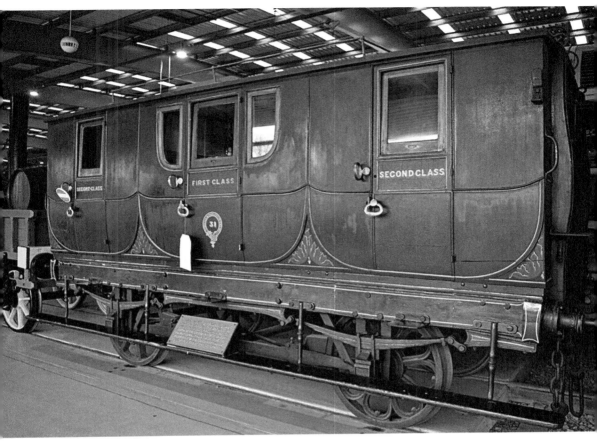

Stockton & Darlington Railway coach No. 31. (The National Rail Museum, Shildon)

overcame many of the weaknesses seen in the early locomotives and proved that steam traction could become a reliable form of transport.

Passenger services became hauled by locomotives in 1833, by which time the Liverpool & Manchester Railway (LMR) had been open for three years and could claim to be the first passenger service hauled by locomotives. Those behind the LMR had the benefit of having observed the pitfalls experienced by the S&DR; no doubt they saw the potential for passenger transport and would have been aware of the problems with the mixing of locomotives and horse-drawn vehicles and the trouble with the reliability of some of the early locomotives on the S&DR. The S&DR was a pioneer and the claims of other railways to be the first in some aspect of the evolution of the operation of railways cannot belittle the enormous step forward taken around the Tees, nor can the contribution the railway made to the development of the towns in the area be ignored.

While the railway heralded a transport revolution, the towns along the Tees were also experiencing change.

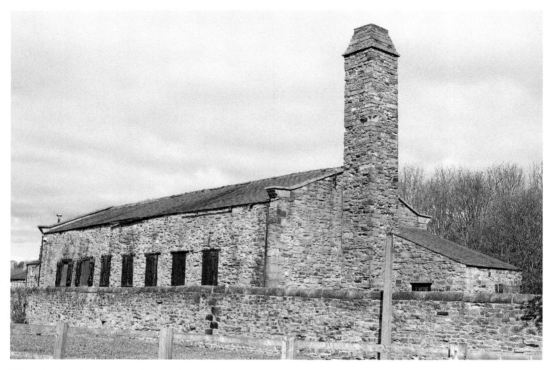

Timothy Hackworth's Soho Works at Shildon.

Middleton in Teesdale

Middleton in Teesdale became the centre of the lead mining industry in the upper reaches of the Tees. By the early eighteenth century the practice in Teesdale was for small groups of miners to work in partnership, taking out a mining lease from landowners over a limited area and working to dig out the lead ore. Lead mining was often used to supplement income from small holdings. The miners were often helped by landowners who operated lead smelting works and would buy the ore, process it and sell the lead. But the organisation changed as mining companies started to take over the leases. These firms brought money, managers, overseers and new methods to increase production to meet the growing demand for lead, which was used in buildings (roofs, gutters and water pipes), in glass making, in lead-based paint, to make lead shot for guns and for export.

The London Lead Co., often referred to as the Quaker Company because of its Quaker ownership, started to operate in Teesdale in 1753 and gradually took more and more leases, agreeing terms for payment of a royalty usually based on the weight of ore extracted. Landowners who had worked with the local miners found it easier and less risky to simply take a royalty from the mine operator rather than be involved in the process of producing lead. While there were others, including the Greenhurst Lead Mining Co., the LLC soon became the major mining business in the area.

Hushing was a traditional method of exposing the ore; this involved constructing a dam to collect water at the top of a hillside and when it was released the force of the water gushing down the hillside washed away the surface soil to reveal the rock. This scouring of the landscape was disliked by farmers, who saw useful soil being washed away, and much further downstream the practice brought objections from Stockton, with complaints that 'hushing in Teesdale ought to be restricted as [it was] detrimental to the salmon fishery of the Tees'. When hushing exposed a lead vein shafts were sunk as the ore was dug. However, as the mines became deeper a number of problems arose: water drained into the workings, ventilation was poor and hauling the mined stone to the surface was difficult.

One solution available in the hills of the Pennines was to dig a level or tunnel into the hillside to reach the lower workings, providing drainage and a route into and out of the mine; the digging of these levels was non-productive and needed the help of the larger firms like the LLC, which had funds enough to pay for this work. As the shafts and levels deepened and became longer, ponies were used to haul tubs of rock along to the surface.

Low Skears Mine near Middleton in Teesdale.

Once the lead and rock, called bouse, was brought out of the mine, the next stage of the process was known as washing. This involved crushing the bouse and separating the lead ore. Historically, this had been undertaken by hand using hammers, followed by sieving the mixture through water and allowing the heavier lead deposits to sink and be collected. Innovations followed; mechanical crushers were developed to pound the stone, the separation of the lead ore was improved and troughs were designed to take the crushed bouse and agitate it through a stream of water to wash away the waste rock. This development improved the separation process and reduced the amount of lead that was carried away with the rock. All this new equipment demanded investment and while the mining companies were able to fund this, it is doubtful that the small partnerships would have had the resources to finance the purchase of new machinery. As an example, £1,500 was paid for a pair of mechanised crushing rollers by the LLC. The company clearly had funds available to invest in machinery; its minute books, for example, would often report on holdings of £100,000 of Government stock in reserve.

The washing process was not totally mechanised and boys were employed to look after the washing troughs. A verse from a song provides a hint of the conditions:

The ore's awaiting in the tubs, the snows upon the fell
Company folk are sleeping yet but lead is right to sell
Come my little washer lad, come, let's away
We're bound down to slavery for four pence a day.

When giving evidence to the Commission on Children's Employment in 1842, one washer boy commented that, 'We sometimes get wet as early as 8 o'clock. It would be a vast deal better if we could go under some place during rain and keep ourselves dry than stand wet all day.'

The mines were in isolated places, and rather than walk miles to and from work each day, the mine workers would stay in buildings known as mine shops, which were built near the mine entrance. At the end of the working week the miners would return to their homes. One traveller commented in 1847 that, 'The shop consists of a single room partitioned into two, with a loft above. The only furniture is a table and two sloping planks with bundles of heather which act as beds.'

The final stage of the process was smelting to remove impurities from the ore and produce lead ingots ready for sale. A traditional method of smelting was in simple hearths, where the fuel (often peat or charcoal) and the ore were placed together and the heat from the burning charcoal was intensified by bellows blowing air across the furnace until

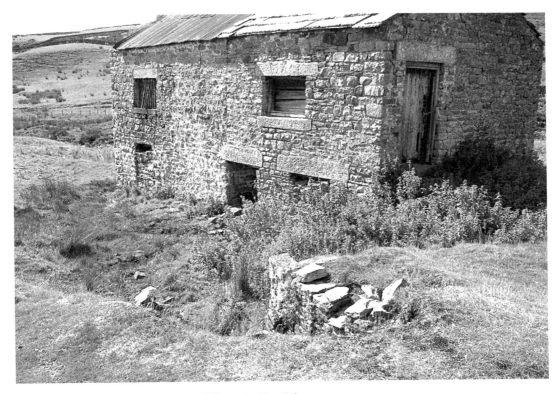

Marlbeck Mine Shop near Middleton in Teesdale.

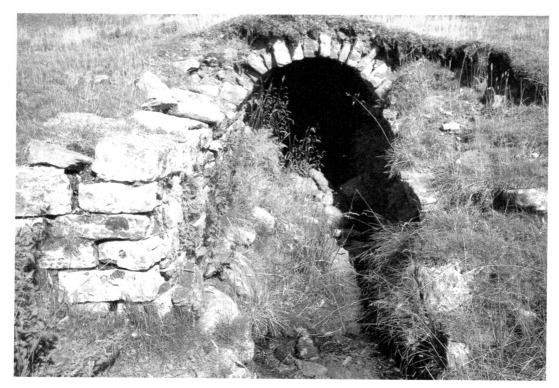

Marlbeck Mine.

the molten lead flowed. However, smelting on a larger scale needed smelt mills. The Bowes Lead Mill at Blackton near Eggleston operated in the early seventeenth century, and there was also a mill built at Langton by the Earl of Darlington. However, it was at Blackton that the LLC developed their smelting operations. In 1771 it took over the mill at Blackton, and as the output of their mines increased there was a need to build a bigger facility, which was opened in 1820 near to the original mill. The smelting process was transformed as new methods were developed; for instance, the LLC introduced the reverberatory furnace, which used coal as a fuel to overcome the difficulty in sourcing the timber that was used to make charcoal. Using coal presented a problem; it contains sulphur, which could impair the purity of the lead. The solution was to have two separate chambers – one for the coal and another for the lead – so that only the heat from the burning coal was allowed to play on the ore. To take away the fumes, a long horizontal flue fed a chimney. This flue allowed the cooling fumes to deposit any lead that had been carried on the smoke before it drifted up the chimney. Of course, somebody would have the unpleasant job of cleaning the flue to retrieve the lead. The landscape was changed in the areas used for mining with washing floors, waste heaps and workshops around the mines, and at Blackton the new chimney would dominate the view. Smelting was a skilled process and could involve the extraction of silver, which was contained in small amounts in some of the ore, and in

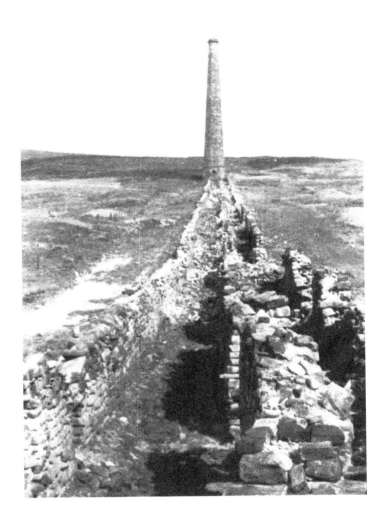

The flue and chimney
at Blackton Smelt Mill
before demolition.
(Beamish Collection)

the 1830s the LLC introduced an improved method of drawing out the silver. This was the Pattinson process, which utilised the different cooling qualities of lead and silver. As the lead started to crystallise, it was drawn off using perforated ladles. The process was repeated until, eventually, the silver was isolated. The smelters were relatively well paid and families would continue the tradition of employment in this skilled work; in Eggleston in 1841, George Dalkin, aged seventy-five, was working as a smelter, as was his son, forty-year-old John, and his fifteen-year-old grandson, George.

Water was used to power much of the equipment as there was adequate supply in the hills around the mining areas. In 1857 a report from Blackton explained that a newly installed turbine was used to provide power for the saw mill on the site. There was a reservoir to supply water to drive the turbine and this was kept supplied by 'water brought from the adjacent hills by an open cut'.

The site of the Blackton smelt mill.

The lead had to be transported; first, from the many mines in the hills down to the smelters at Blackton, then the refined lead would have to be taken to the markets and ports for shipping. The roads in the area were poor and wagons could not be used, so trains of ponies with pannier baskets on their backs would be led across the tracks. The LLC did make some improvements to the roads, particularly the one from Eggleston to Stanhope, where the processed lead could then be carried with the output from the LLC's mines in the northern part of the region to Newcastle and its port.

The LLC set up its northern headquarters at Middleton in Teesdale in 1815 and erected grand offices. The firm also developed a community in the town and built houses in a part of the village that became known as Newtown. This little suburb was designed by Ignatius Bonami, who is perhaps better known for the design of the bridge that crossed the River Skerne in Darlington to carry the Stockton & Darlington Railway. A welfare scheme was operated and a doctor was appointed to look after the miners and their families. A shop was built and the shopkeeper was required to set prices at a reasonable level. In 1818 a school was opened and boys attended between the ages of six and twelve while girls stayed on until fourteen. As well as school, children were also expected to attend Sunday school and 'twice on the Sabbath day, such places of worship as his or her parents may think proper'. In order to find work with the company a boy had to have attended school and have 'been of good behaviour and industrious'.

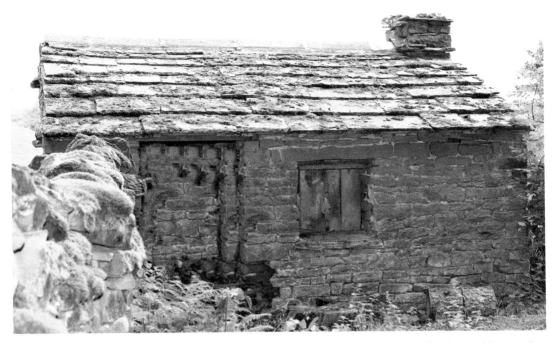

Saddle House near Eggleston. It is thought that saddles were stored here for the packhorses that carried the lead to the smelt mill.

A section of the packhorse route near Eggleston.

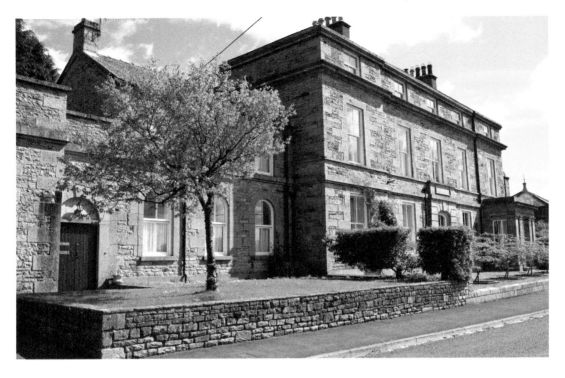

Above: Middleton House, the headquarters of the London Lead Company.

Left: The archway at the entrance to the housing built by the London Lead Company.

It can be suggested that the Quakers were benevolent employers, encouraging welfare schemes, building homes and schools. A picture of an idyllic life in the new town could be imagined, or perhaps this can be viewed as a way of encouraging compliance and acceptance in this remote location. Some of the social unrest seen in the years between 1830 and 1840, when Chartism became the banner behind which much discontent was expressed, does seem to have been avoided. Nevertheless, mining was hard, manual work with picks, hammers and wedges used to hack at the rock, although by the eighteenth century gunpowder was being used to blast into the rock. Those working underground suffered deteriorating health from the dust swirling around the galleries. A report looked at the life expectancy among Teesdale miners and found the average age was forty-seven. Pensions for those aged over sixty-five were available from the company's benefit fund, which all employees were required to contribute towards; in 1864 there were 1,063 members, but only sixteen of those were over sixty-five.

The LLC invested heavily in mines and smelters and the production of lead was increased. In the years between 1816 and 1818 the LLC was producing around 1,700 tons of lead a year; a decade later it was over 6,000 tons. To achieve this an organisation had to be developed to organise and control the operations and workforce. Over men were appointed to supervise the miners and wages were based on the amount of ore extracted. A bargain was made with a group of miners, usually four, for payment per bing (or 8 cwt) of dressed ore produced in a three or four-month period. Alternatively, where 'dead works' were needed, such as excavating levels, the pay would relate to the length dug. Payment would be calculated at the end of the period but in the meantime a monthly advance would be made, with any balance due paid at the end; or, if there was an overpayment, this would be carried forward. In setting the level of payment the ease or difficulty of the mine working would be considered and the company had agents who would inspect the mines and assess conditions before rates were set. The miners would have to provide their own tools and pay for the gunpowder and candles they used, as well as for the washing of the ore. Robert Stagg, the local superintendent, saw one opportunity to reduce pay and he reported that this had a positive impact on the miners' welfare and encouraged a 'sensible improvement in their moral habits' by keeping wages below the level that would allow alcohol to be bought, stating, 'Drunkenness is comparatively abolished among them, and those lavish and extravagant habits, induced by their former high wages, are in a great degree corrected.'

The LLC was controlled by a board of governors but the management of the lead mines in the North Pennines was undertaken by a superintendent who was supported by local agents. Robert Stagg had started with the company first as a washer boy and had then worked in smelt mills and in the accounting offices. He was appointed as the company's superintendent in 1816. Stagg experimented with the smelting process and introduced developments that made the Blakton Mill one of the most efficient in the country. While Stagg became respected and his achievements were recognised by his employers, his activities were nevertheless subjected to audits and reviews. In July 1821, Thomas Howe, the deputy governor, along with some of his colleagues, visited the North with instructions to 'examine into the state of the company's accounts, to suspend, discharge such of the company's agents and servants as they shall find occasion to do according to their discretions and to give orders on any other matter or thing that shall by them thought for the benefit of the company'. Their report was given in November and was complimentary about Stagg's work. As a result, his annual salary was increased from £1,000 to £1,200.

Barnard Castle

Moving downstream, Barnard Castle was the market town for the district. In 1747 the distinctive octagonal town hall was built and the lower floor provided a market place as well as a jail. When Daniel Defoe toured the country in the 1720s he found that at Barnard Castle 'the manufacture of yarn stockings continues this far, but not much farther'. Defoe highlighted a cluster of towns stretching across the Pennines to Richmond in North Yorkshire and Barnard Castle, and he explained that the 'trade [in making stockings] comes from Westmoreland, at Kendal, Kirkby Stephen and such other places as border upon Yorkshire.'

By the late eighteenth century there seems to have been a growth in wool processing. In 1776, for example, the town was described as having 'a great manufactory carried on here in woollen goods, tammies, shags, crapes and stockings. The place in early times was famous for leather and at this day many wealthy tanners reside here …. it has one of the greatest corn markets in the north of England'. The wool industry here provides an example of the manufacturing process before the mechanisation of the work. It was principally operated as a domestic industry, where merchants would deliver materials to those spinning the wool or weaving the yarn in their homes. The finished goods would then be collected, payment made and the next batch delivered to be worked on. This putting out system did not survive when the process of producing textiles became mechanised as the machinery could not be used in a domestic setting. Consequently, the work was moved to factories and mills.

'Dark satanic mills', immortalised in William Blake's poem, were built along the riverside below the castle and water was used as a source of power until steam engines were introduced. In 1834 a directory noted that water mills for spinning yarn were situated beside the Tees. This would include Ullathorpe Mill, which eventually had its machinery powered by steam engines.

Carpet manufacturing became one of the main industries in Barnard Castle. The Monkhouse family were founders of some of the mills, and according to Mr J. W. S. Monkhouse when he was speaking in 1859 about the early days of carpet weaving, it was the great number of unemployed that encouraged him to start the business. By 1836 there were over 400 looms producing carpets and this work attracted families into the town. The population increased – in 1801 there were 2,966 inhabitants and by 1851 this had risen to 4,608 – and the carpet industry supported one quarter of the townsfolk.

This expansion meant more housing was needed and the rush to provide accommodation led to some significant problems; it will be seen that this was not unique and other towns in the Tees Valley as well as throughout the country suffered the consequences of

unregulated expansion. Barnard Castle saw houses crammed in poorly ventilated yards with inadequate sanitation and water supplies. In 1851 the 'Report for the General Board of Health of the Township of Barnard Castle' looked at the conditions. Comments on drainage noted 'those designated as main sewers are merely surface drains and in

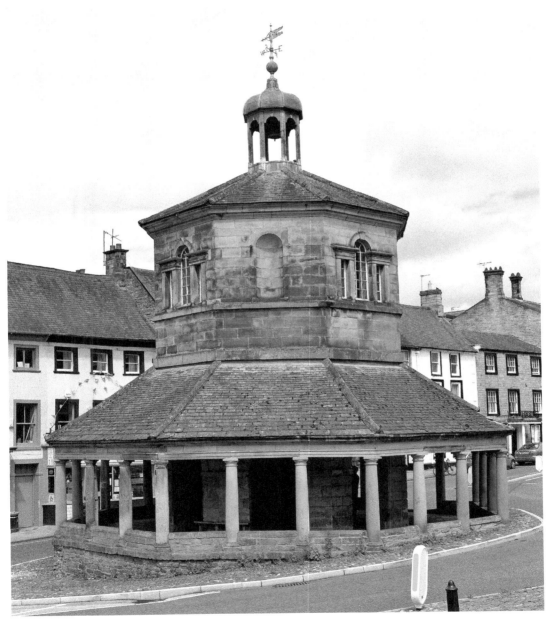

The octagonal market building at Barnard Castle.

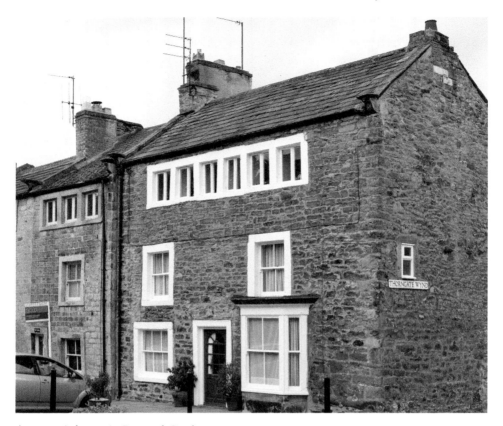

A weaver's house in Barnard Castle.

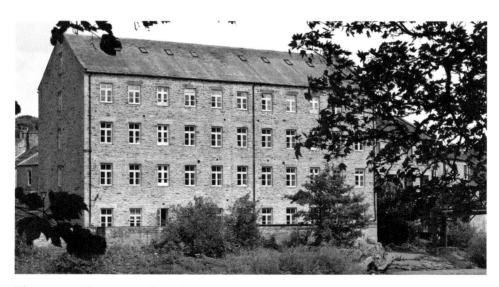

Thorngate Mill at Barnard Castle. It has now been converted to flats.

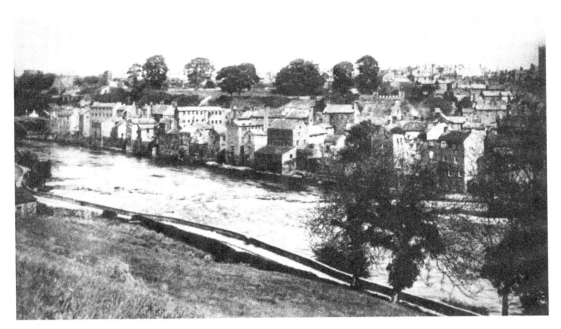

The industrial area at Barnard Castle.

some parts even surface drains do not exist' and that housing was overcrowded: 'Each house [is] divided into separate tenements of one room where up to six people live. Pigsties, dungsteads and open privy pits are in many places under windows.' A doctor reported how he had found in one house two people and a child occupying a single room 'without any article of furniture, except a bed on the floor, but no covering of any kind; a sack was nailed to the widow opening [and there was no glass]'. These poor conditions, together with a problem emanating from the graveyard, which was situated above much of the town and drained down towards the industrial area, contributed to a devastating outbreak of cholera in 1849. A total of 149 people died and the 'plague town' was shunned by many, including businessmen, who hesitated before visiting the factories. Mr John Pratt, the owner of a carpet mill, which in 1836 had eighty looms, was struck down by a violent attack of the disease and died within a day of first feeling ill. His daughter, fourteen-year-old Catherine, followed him a few hours later.

The manufacturing businesses did not prosper. The two mills of Messrs Monkhouse – one of which had been used for carpet manufacture and the other for woollen cloth – were advertised for auction in 1859. The loss of employment caused great concern in the town; a carpet manufacturing cooperative was proposed but only the woollen side of the business survived. The Tees Woollen Manufacturing Co. took a lease on one of the mills in 1861, but the firm did not last and a new occupier was being sought by 1863, with Messrs Taylor from Leeds taking over. The carpet-weaving enterprise declined due to the invention of linoleum, which provided strong competition for the thin, reversible Kidderminster carpets that were produced in the town. There was also a lack of innovation in the carpet designs, the manufacturers being content to produce the same designs year after year while other firms paid artists to design new patterns.

The cost of transport from this relatively remote spot was also a problem. Among the Monkhouse family were local chemists and grocers, as well as carpet manufacturers, and along with more of the town's business people they campaigned for a railway. By the time a line reached the town, the carpet industry was in difficulty. By 1861 there were only forty-nine carpet weavers in the town compared with 275 a decade earlier. There was no significant industry introduced to replace carpet weaving but the manufacture of thread that was used by shoemakers continued in the factory of Ullathorpe & Co.

One business that has survived into the twenty-first century was founded by William Smith, originally to make farm implements. In 1863 he was working on a new grass-cutting machine that was imported from America when he spotted an innovation to improve the performance of the cutter. He patented this and was soon selling his new version of the mower. He next turned to street cleaning and he produced a street scraper to clear dust, rubbish and horse dirt and, in 1865, a sweeper. These road cleaners were a success and were bought to clear the streets of towns throughout the country.

Manufacturers and traders in the town were aware of the advantages that a railway would bring, and in the 1830s a proposal was made for a line linking with the Stockton & Darlington Railway. Edward Pease warned of the difficulty that would be encountered with Henry Vane, who held the titles of Lord Darlington and the Duke of Cleveland. The line would have to cross the Duke's land and Edward had to remind the

Advertising poster for the Ullathorpe Yarn Mill. (Beamish Collection)

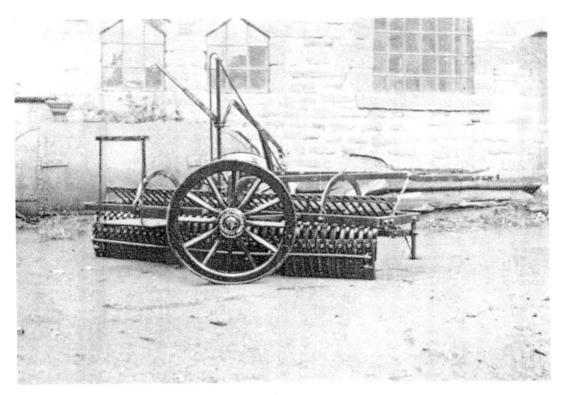

William Smith's road scraper. (Beamish Collection)

group of the effort the Duke had gone to to defeat the S&DR. When Henry Witham of Lartington Hall, a local landowner and benefactor, visited the Duke to discuss the proposal for a railway to Barnard Castle, he came away from the meeting with a refusal in such 'terms that … he could take no further steps in the matter'.

Further attempts were made to promote a railway, all of which were opposed by Lord Darlington, who did not want 'this very objectionable line … [through what] may be called the Garden of Eden'. However, there was a growing interest in reaching Barnard Castle and the potential benefits that would follow if the railway continued across the Pennines. The Barnard Castle & Bishop Auckland Railway was proposed by Hartlepool interests, led by Ralph Ward Jackson, who was a constant thorn in the side of the S&DR. This line was also supported by interests in Sunderland and Newcastle, who saw the end result as a line across the country to Liverpool. The S&DR had to act to preserve its position and surveyed a route to avoid Lord Darlington's land. There were two lines to be considered. The S&DR line carried most of the support in Barnard Castle and it was this line that was approved as, of the two, it was the line that presented the simplest engineering. Nevertheless, there were problems during the construction of the line; in October 1855 two bridges across the Tees near Gainford were carried away when the water level in the river surged. These then had to be rebuilt to a design that would withstand the Tees when it flooded.

In July 1856 the line from Darlington to Barnard Castle was opened and the *Teesdale Mercury* reported on the celebrations that ended years of waiting: 'At ten o'clock a

RAILWAY.

Notice is hereby given.

THAT A

PUBLIC MEETING

WILL BE HELD IN THE

INFANT SCHOOL ROOM,

BARNARD-CASTLE,

On Thursday, the 7th day of November Instant,

AT 1 O'CLOCK IN THE AFTERNOON.

For the purpose of taking into consideration, the propriety of forming a RAILWAY, from Barnard-castle, to communicate with the Stockton and Darlington Railway.

H. T. M. WITHAM, ESQ.

HAS CONSENTED TO TAKE THE CHAIR ON THE OCCASION.

Barnard-castle, November 2nd, 1839.

A notice for the public meeting that would be called in 1839 to discuss the formation of a railway. (Centre for Local Studies, Darlington)

The railway bridge near Gainford.

crowded excursion train left for Darlington and Redcar. At two o'clock a variety of sports commenced in Galgate. The first was climbing the greasy pole'. The arrival of the railway brought an opportunity to encourage visitors into the town to explore the picturesque valley of the Tees and a local firm of printers and stationers, Messrs Atkinson, produced a new guidebook in 1858 to support the burgeoning tourist trade. When the line was extended to Middleton in Teesdale in 1868, the villages along the line were also able to attract excursionists. Cotherstone, in particular, became a favourite haunt for visitors.

Darlington

In the eighteenth century Darlington was a compact town contained within the boundaries of Skinnergate, Bondgate and Northgate, and just across the River Skerne to the east there was Clay Row. Darlington was on the Great North Road and the local inns, including The Sun Inn and The Dolphin, served travellers. The town, as well as holding a weekly market, supported a number of trades; leather was worked and in 1753 a traveller noted that in the River Skerne 'grow the green, round reeds … which they use here to make mats, chair bottoms and bed bases'. However, Darlington had developed a reputation by the eighteenth century for the production of a stout linen fabric used for towelling called huckaback. Flax, the raw material, was imported from Holland to be processed, spun and woven into linen. There was a stamp mill in the town where the flax was softened before being spun into thread, and there were also mills with looms to weave the huckaback and to make cloth for petticoats, sheets, tablecloths and men's waistcoats. By 1791 the *Universal British Directory of Trade, Commerce and Manufacture* stated that the principle manufacture of the town was 'linen and woollen, of which the former exceeds that of any town in England'. But the town's position as a significant producer of linen was not to continue and other areas of the country were to become dominant in linen processing despite the pioneering work of two of the town's entrepreneurs.

John Kendrew and Thomas Porthouse set about bringing the advances to flax spinning that had been made in the manufacture of wool and cotton textiles. An early invention came in 1733 with Kay's flying shuttle; however, as the weavers increased output there was not enough thread available to work. Those spinning the fibres into thread with their simple spinning wheels could not keep up with demand. Three inventions began to provide solutions. First came the spinning jenny, then Arkwright's water frame, which was patented in 1769. Then, around 1778, Samuel Crompton produced the spinning mule, which produced a finer thread.

In Darlington, Kendrew and Porthouse invented a machine for spinning flax. Kendrew had established himself as a grinder of quality optical glass and had grown his business and expanded into the Low Mill, which was adjacent to the Skerne. However, it seems that tradesmen from Birmingham started to compete using similar machinery in their workshops; Longstaffe declared in his book *The History and Antiquities of Darlington* (published in 1854) that 'they pirated Kendrew's invention, and his trade died out'. Porthouse brought the skill he had developed as a watchmaker to the project and the two experimented, until by 1787 they were able to set up a flax spinning operation at

A traditional spinning wheel.
(Beamish Collection)

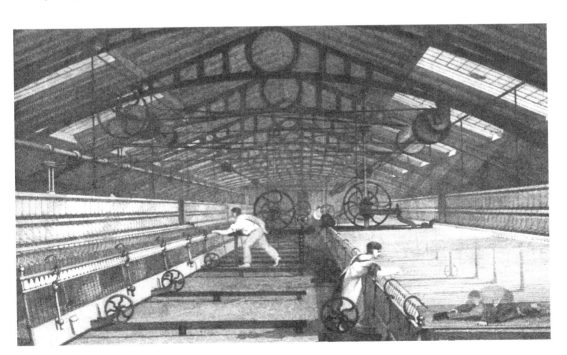

A spinning mill.

Low Mill. The equipment was patented with the help of Jonathan Backhouse, who was in business as a flax dresser and linen manufacturer.

James Ayton visited the town and arranged to license the use of the spinning machinery in his business in Scotland. John Marshall of Leeds also negotiated with the partners to use the spinning frame and agreed a royalty payment, but when he stopped making the payment the Darlington pair took legal action, only to lose when Marshall successfully argued that he had developed the machine to such an extent that it no longer resembled the original invention. Kendrew and Porthouse had to make a living; their invention had not provided them with riches so they went on to set up their own mills, Porthouse at Coatham Mundeville and Kendrew at Haughton-le-Skerne.

The linen industry did not flourish in the town. In 1827 there were still some flax spinning enterprises in the town: Ianson, Tomlin & Ord in Priestgate and Edward Parker & Co. in Haughton. However, by 1837 the business in Haughton failed. Charles Parker, who was by then was running the firm, was declared bankrupt in April, and the flax mill, with 'ample warehouses, counting house, smith's shop and two powerful steam engines', was advertised to be sold at auction at The Sun Inn in Darlington. By 1855 the linen industry was reduced to one flax spinner, J. Overend & Co. at New Mill.

It was noted above that the *Universal Directory* recognised the woollen industry as a major part of the economy of the town, but before this is looked at in some detail it is necessary to introduce two of the families that played an important part in the development of industry and towns in the Tees valley.

Edward Pease (1711–1785) arrived in the town in the mid-eighteenth century to work in the wool combing business of his uncle, Thomas Couldwell. When Thomas died Edward took over the business and expanded its operations to all stages of the manufacture of woollen cloth, including spinning, weaving and dying. The work was gradually brought into two mills; one in Priestgate, the other in the Leadyard. At first the mills supported work undertaken on the 'putting out' system. Parts of the mills were little more than warehouses, where finished work was returned by those who had been working on it in their homes and from where the next batch was collected. When Edward died he left the woollen business to his son Joseph (1737–1808), who, while his father was still alive, had continued to work at developing trade and had opened a local bank to support the trading business. Another bank had been started in 1774 by James Backhouse, which, like the Pease bank, was originally set up to support the family trade but would soon become the main business, with branches through the region. Both families were members of the Society of Friends or Quakers and soon an alliance between the families developed when Jonathan Backhouse, the son of James, married Ann Pease, Joseph's sister. At this time Quakers were obliged to marry within the sect if they were to avoid being excluded from the Society and links with Quaker families throughout the country were common. A member of the Gurney family, who were from Norwich and involved in the woollen industry and a banking business, married Jonathan Backhouse Jnr. These families would soon play significant roles in the financing of the Stockton & Darlington Railway. The Gurneys also became associated, through marriage, with another family involved in banking, the Barclays. In 1826 Joseph Pease married Emma Gurney, and when he needed funding to purchase land and develop Middlesbrough, his father-in-law was able to help with a loan.

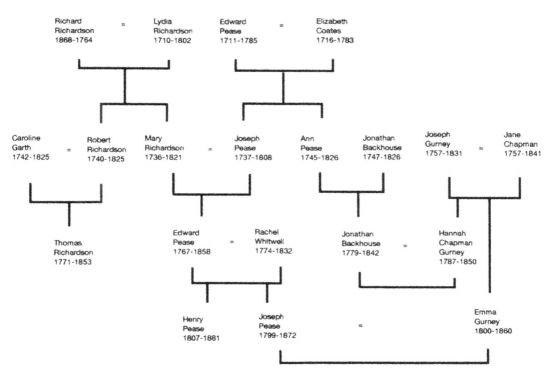

An outline of the Pease family tree.

Edward Pease (1767–1858) entered the woollen business and eventually took over from his father, Joseph. However, his role in possibly one of the most significant events of the early nineteenth century, the construction of the S&DR, led to him being crowned the 'father of the railways'. The gestation of the first railway is considered in more detail in the chapter about transport but it is worth noting here the extent of the Quaker contribution in financing the railway, with the Pease and Backhouse families providing £26,000, the Gurneys £20,000 and £10,000 coming from Thomas Richardson, a cousin of Edward Pease.

The Pease businesses expanded as the S&DR laid more and more lines; collieries were leased, the mills continued to provide work in Darlington, Middlesbrough was developed and mines opened in the Cleveland Hills when ironstone was discovered, all supported by the J. & J. W. Pease Bank. One mark of their prosperity was the fine houses they bought.

In Darlington the Pease wool business was not forgotten and it became a major employer in the town as the mills were developed and as machinery was introduced. A letter survives recounting the understanding that 'Pease's was the third mill in England where worsted yarn was spun by machinery'. This is possibly a reference to a worsted spinning machine supplied in 1796. However, the Darlington business was not always successful and Edward Pease recorded in his diary in 1842 how he 'entered with my three dear sons into serious conversation as regard the mill concerns. The distress it would cause the poor and the loss of £30,000 to £40,000 to the family would render it prudent to try for another year'.

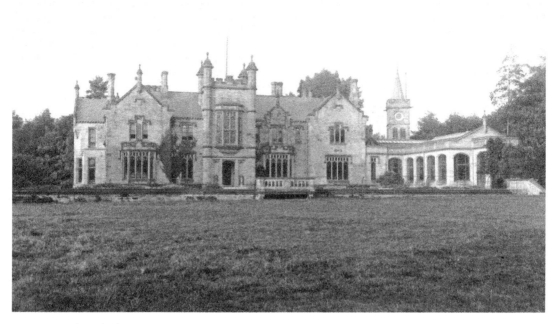

Pierremont, bought by Henry Pease in the 1840s. (Centre for Local Studies, Darlington)

The mills provided work for many, including women and children, and to provide for themselves in case of illness or disability a Women's & Children's Association was set up. In 1814 members were contributing a penny or two each week and those in need were given a payment of 4s (20p) from the fund every four weeks. The membership records of the Association suggest that girls were employed in the mills; in 1814, Phoebe Cook and Elizabeth Phillips, who were both born in 1805, were recorded as contributing to the fund.

The Pease business operated from the Priestgate Mill, Low Mill and East Street Mill, which were all close to the town centre and the River Skerne. Then, in 1837, Pease took over the Railway Mill at the northern edge of the town, which was reputed to have 400 weaving looms. This new mill was a final blow to the domestic workers and soon the days of the hum of the spinning wheel and the click clack of the loom mingling together in homes were gone as work was taken into the mills. The impact of these changes was felt in the local villages. In Hurworth, home-based weavers could not compete with the mechanised factories and were unable to produce cloth at a rate that would give them an adequate income. Some turned to the railway and work as navvies constructing the line that was being built between York and Newcastle.

But there were also other trades in Darlington; in the nineteenth century carpets were manufactured by Francis Kipling and William Thomson but they were not able to establish the town as a centre of carpet production, as was seen locally in Durham and for a while in Barnard Castle. The Kipling operation was abandoned in 1855.

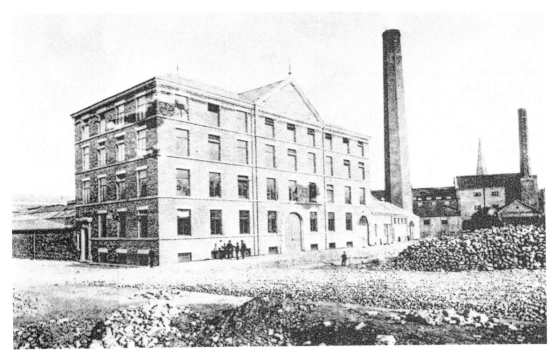

Pease Mill. (Centre for Local Studies, Darlington)

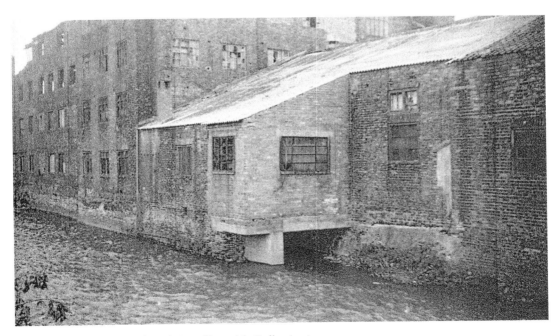

Pease Mill before demolition. (Beamish Collection)

The S&DR opened in 1825 and this gradually brought opportunities for new industries to develop. The early beginning of one firm can be traced back to 1790 when William Kitching opened an ironmongers shop in Tubwell Row and later added a foundry. William was succeeded by his sons, William and Alfred, and they started to receive orders from the S&DR, initially just for nails and then for wagon parts. In the early part of the 1830s they set up a foundry near the railway in the Hopetown area; this part of the business was looked after by Alfred and was developed to build coaches and locomotives, including, in 1845, *Derwent*. There was another foundry in Hopetown, which was operated by William Lister. This was taken over by Kitchings and Alfred handed over the running of this business to his cousin, Charles Ianson.

The S&DR saw the town was developing a railway industry and in 1853 decided to build a carriage works in Hopetown. Then, in 1862, Kitching offered the original Hopetown factory to the S&DR. The remaining Kitching factory continued to operate and became the Whessoe Works. The S&DR continued to increase its presence in Darlington and the North Road Locomotive Works were opened in 1863, by which time the S&DR had been absorbed into the North Eastern Railway. By 1870 the 'North Road Shops' provided employment for around 500 people.

The influence of the railways was also felt in the Bank Top area, where the Great North Eastern Railway (GNER) built a station and depot on the line from York to Newcastle. The GNER and S&DR lines were to influence the siting of new industrial development at Albert Hill, which was conveniently sited between the two lines.

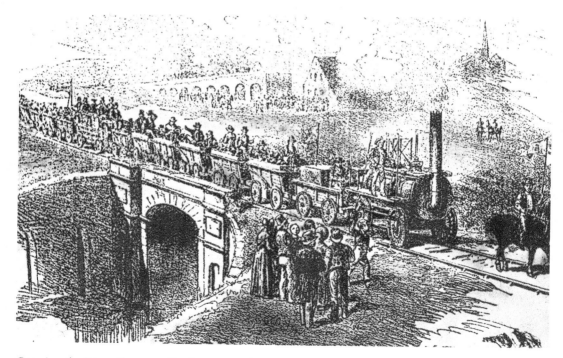

Crossing the River Skerne at Darlington on the opening of the Stockton & Darlington Railway. (Beamish Collection)

48

The rail bridge crossing the Skerne is still in use.

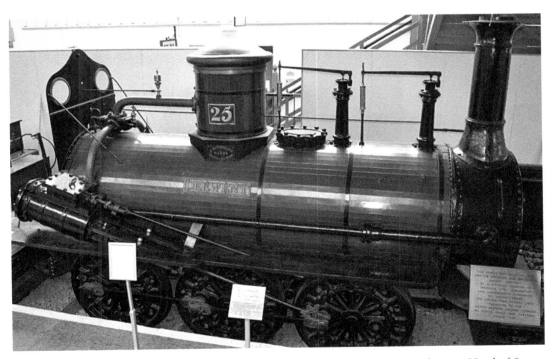

The locomotive *Derwent*, which was built in Darlington by Kitching. (Darlington Head of Steam Rail Museum)

Access to a railway was so important in those days that using horse-drawn wagons was considered an inferior alternative for transporting heavy and bulky loads.

Soon after the uncovering of the ironstone deposits in the Cleveland Hills in 1851, Albert Hill was attracting engineering businesses. The Darlington Forge opened in 1854 and two more firms followed – John Harris's foundry and the South Durham Iron Works with two iron-producing blast furnaces. Put very simply, the stages in the production of iron involve heating iron ore in a blast furnace together with coke and lime as a flux to remove impurities and form a slag. A fierce blast of air produced a high temperature and the molten iron was run from the furnace into a channel with smaller channels running from it – these are known as pigs. The resulting pig, or cast iron, is hard but comparatively brittle, so the next stage is puddling to remove most of the carbon that was introduced by the coke. This process leaves wrought iron, which is not as brittle as cast iron and can be shaped by hammering or rolling. Puddling was another innovation from the Industrial Revolution, as the process of heating the pig iron from a coal fire that was in a separate hearth from the iron and stirring the molten iron to remove the carbon was developed by Henry Court by 1784.

More industry was attracted to Albert Hill, including the Darlington Iron Co. in 1859, which operated puddling furnaces, and the Skerne Works, which had many members of the Pease family as partners and produced plates for ships, boilers and bridge sections. Across the town in the Whessoe/Rise Carr area, rolling mills were set up by Ianson, who had taken over the Kitching business.

Housing had to meet the demands of the growing numbers in the town; initially homes were built in the gardens of the houses in High Row and these grew into the yards that are still evidenced between High Row and Skinnergate. The area around the

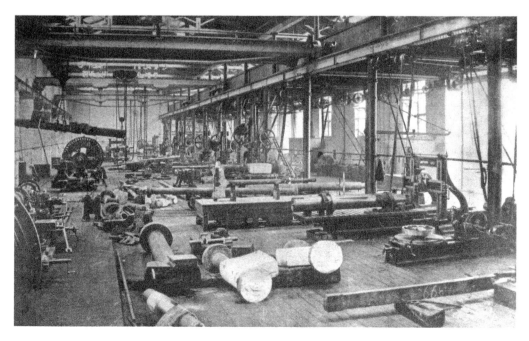

Darlington Forge. (Centre for Local Studies, Darlington)

Darlington, November 14th, 1867.

Sir,

We beg to inform you that we have this day entered into Partnership for the purpose of carrying on business as Railway Wagon Builders.

We have purchased on very advantageous terms the extensive premises late in the occupation of Messrs. Harker & Pickering, at Albert Hill, Darlington, consisting of three spacious Wagon Shops, with upwards of Two and a Half Acres of land.

The Works are very eligibly situated near the junction of the Darlington Section of the North Eastern Railway with the Main Line, the Railway of the Darlington Section forming the southern boundary of the Works, and being connected therewith by private lines of rail.

We are fitting up the Works with the most approved Machinery and the best appliances for diminishing labour and expediting the despatch of work, and we believe we shall be in a position to compete with any other Establishment both as regards quality and price.

We are glad to inform you that we have secured the services of Mr. William Davison, of Shildon, as Manager of our Works. He has been in the employment of the Shildon Works Company for upwards of Eleven Years, and is thoroughly and practically acquainted with the business in all its branches, and comes to us with the highest testimonials from his late employers.

Our style and title will be "The Darlington Wagon Company," and the official duties of the Firm will be performed by our Mr. Wilson, whose signature on our behalf is appended hereto.

We are, Sir,
Yours faithfully,

JOHN WILLIAMSON,
JAMES WILSON.

Mr. James Wilson will sign. *For Darlington Wagon Co yself*

A letter regarding the opening of Darlington Wagon Works at Albert Hill. (Reproduced by permission of Durham County Record Office Cp/Shl 16/4)

51

The frame of a steam hammer from the Darlington Forge, which is now at the entrance to Beamish Museum.

town centre became overcrowded and disease spread, with conditions that were similar to those in Barnard Castle. The 1850 Report of the General Board of Health noted that in the yards of Darlington, 'medical treatment can prove of little avail so long as so many ... cesspools, obstructed drains and pools of stagnant water are allowed to exist'. Gradually the town began to expand from its historic boundaries, and the area between Northgate and Bondgate on the northern side of the town saw Commercial Street, Queen Street and Union Street developed. Away from the central part of the town, housing was built in the Hopetown and Albert Hill areas to accommodate those working in the new industries.

The Darlington Iron Company Limited.

Manufacturers of Rails, Fish Plates, Switches & Crossings, and other Permanent Way Materials.

MERCHANT BARS, ANGLE & T IRON.

AND OTHER SECTIONS FOR CONSTRUCTIVE PURPOSES.

LONDON AGENTS
FOR
PERMANENT WAY MATERIALS
MESS. THOMSON & BROWNING
3. VICTORIA ST.
WESTMINSTER.
S.W.

Albert Hill & Springfield Iron Works. Darlington.

Darlington Iron Co. letterhead. (Teesside Archives)

The town had been transformed. It was expanding away from the historical boundaries and was providing employment in engineering, the railways and in textile manufacture. The increase in population was amazing: in 1767 there just over 3,000 people in the town, but by the time the 1871 census was taken the numbers had risen to 27,729. Between 1851 and 1871 a spectacular increase in numbers was recorded by the census, with a 139 per cent increase from the 11,582 people counted in 1851. The report that accompanied the census for 1871 noted that the 'increase in population in Darlington was due … to the introduction of the manufacture of iron, the erection of blast furnaces, rolling mills, forge works and engine building works'.

The next town along the Tees to be visited is Yarm, but one village on the way did not escape the advance of industry, with blast furnaces being built at Middleton St George from 1864.

Yarm

Like most of the towns in the Tees Valley, Yarm changed during the Industrial Revolution, but the experience was different from the other towns in the lower reaches of the river. Darlington, Stockton and Middlesbrough all grew and developed major industries; however, Yarm did not enjoy any significant growth, and while some new businesses were started, the town lost its advantage and struggled to develop during this period.

In the eighteenth century Yarm was an established port with considerable trade exporting local agricultural produce such as grain, butter, cheese and bacon together with the output from the lead smelters in Swaledale. Imported into the warehouses and stores along the riverside to the east of the town were hides, timber and flax. The river at Yarm is a considerable way from the open sea but this was not the limit of the Tees as a navigable river and ships did sail as far as Worsall, a few miles further upstream. The facility here, which was called Pierseburgh, was built in the early decades of the eighteenth century by Thomas Pierse. Even though it was so close to the facility at Yarm, it did attract cargoes as water transport was used whenever possible in preference to the often difficult carriage on the roads. The turnpike road from Richmond to Yarm and Stockton passed close by Pierseburgh and lead brought from Swaledale was transferred onto barges for shipping to Stockton. However, there was a limit to the size of ships that could be handled at this facility and growing trade demanded the use of larger ships. Thomas Pierse Jnr took over the firm when his father died in 1770 but he could not make the business profitable and was declared bankrupt in 1779. The advertisements for the sale of his assets included farmland and buildings at Worsall as well as the warehouses and granaries, which were promoted as being ripe for development as a cotton mill at little expense with power readily available from the river.

Yarm as a port did not prosper. Like Worsall it suffered from the limited size of ships that could be handled and competition arrived from the south when a navigable route from Boroughbridge to Hull was completed in the second half of the eighteenth century. This provided a faster route to the London and overseas markets for many producers in North Yorkshire.

Yarm suffered another blow when its neighbour, Stockton, built a bridge across the Tees in 1769, meaning that many ships could no longer sail under the bridge and on to Yarm. Additionally, the bridge connected Stockton with North Yorkshire and local farmers could now bypass Yarm and bring produce to the market and the port at Stockton, which was becoming the dominant port on the Tees.

Piersburgh is still recalled at Worsall.

The folk of Yarm continued to cling to their maritime heritage, with some shipbuilding still being carried on into the 1840s. In 1812 traders set up the Yarm & Cleveland Shipping Co. with the objective of building ships and running a service between Yarm and London. This was not a success, however, and only a year later newspapers advertised a shipbuilder's yard as, 'For Sale. Quantity of sound oak and elm timber. Tree steamer and materials in the building yard at Yarm.'

Nevertheless, there was some new industry. Across the river, on the Durham side, Charles Bainbridge built a paper mill in 1832 and grain was brought into the town to the flour mills that were constructed, including the Wren & Sons steam flour mill of 1849. An early glimpse of the chemical industry was seen next to the railway at Early Nook in 1833 when Robert Wilson of Yarm set up the Eaglescliffe Chemical Co. to produce fertilisers and sulphuric acid. This is yet another example of railways influencing the choice of the site of factories where the benefits of cheap and easy transport were readily available.

In 1855 the town was summed up in a trade directory: 'The manufacture of flour is extensive and several mills are in the vicinity of the town, also there is an old established paper mill. The export of corn at one period was very considerable and granaries and warehouses were established but these are now chiefly un-tenanted.'

Yarm had the benefit of being – at least until the bridge was built at Stockton – the lowest crossing point on the Tees, via the stone bridge that had stood since the fifteenth century. The turnpike road that ran from Sunderland to Catterick passed through Yarm and the town provided inns for travellers. In 1802 a new turnpike road was proposed to link Yarm with Thirsk, with a section to Stokesley. At the intersection of the two branches of the road the Cleveland Tontine was opened as a coaching inn. The proposals for the road included a new bridge at Yarm to cope with the increased traffic that was anticipated. The bridge was opened in 1805 and collapsed a year later, but it was not replaced; rather, the existing bridge was widened. This is still the bridge that crosses the river today and on the riverside walk around the town the two sections can be seen on the underside of the bridge.

Unlike most of the towns along the Tees, there was no great increase in the population of Yarm during the nineteenth century. In 1801 there were 1,300 people in the town; in 1821 there were 1,504 and the census figures for 1851 show an increase to 1,647.

A surviving warehouse in Yarm, dating from the eighteenth century.

However, by 1881 the numbers were back down to 1,485. The 1851 figures reflect the work that was going on when building the rail viaduct across the town, with that year's census recording many rail workers lodging in the town. The local traders experienced a boom as well; in particular the pubs, where the navvies would congregate and end the night with brawls and fights.

Mount Grace Bar.	Mount Grace Bar.	Mount Grace Bar.
Day of 18	Day of 19	Day of 18
Toll paid for	Toll paid for	Toll paid for
This Ticket from Borrowby and Jenter House Bars by paying half a Toll, and clears North Kilvington entirely.	This Ticket from Borrowby and Jenter House Bars by paying half a Toll, and clears North Kilvington entirely.	This Ticket from Borrowby and Jenter House Bars by paying half a Toll, and clears North Kilvington entirely.

Above and below: Turnpike toll tickets. (North Yorkshire County Record Office)

Kirkleavington Bar.	Kirkleavington Bar.	Kirkleavington Bar.
Day of 19	Day of 19	Day of 14
Toll paid for	Toll paid for	Toll paid for
This Ticket from East Rounton Bar by paying half a Toll.	This Ticket from East Rounton Bar by paying half a Toll.	This Ticket from East Rounton Bar by paying half a Toll.

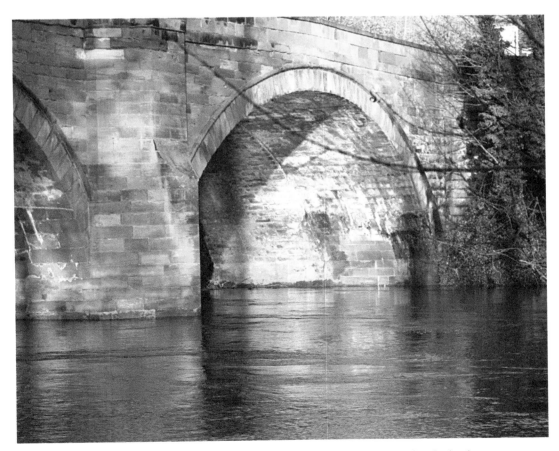

The bridge at Yarm was widened and the two sections can be seen under the bridge.

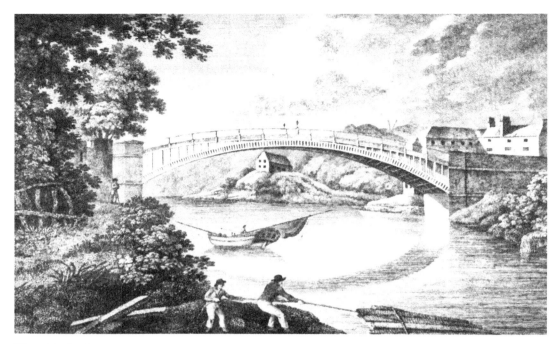

The 1805 bridge at Yarm.

The railway viaduct in Yarm.

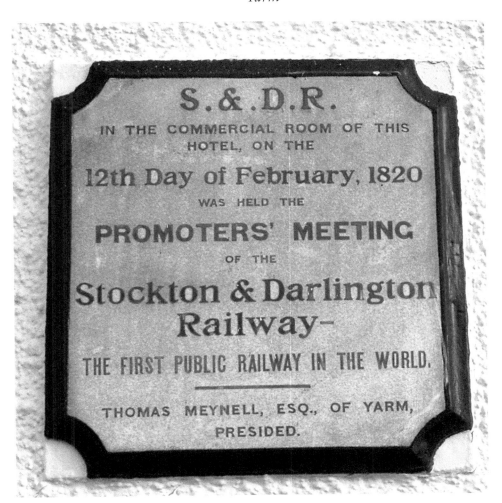

The plaque on the wall of the George and Dragon Inn, Yarm.

The rail viaduct was started in 1849 and took two years to build for the Leeds & Northern Railway's route to Stockton. A new station was built at the northern end of the viaduct, which was much closer to Yarm than the nearest one on the S&DR, which was in Eaglescliffe at Allens West. There was a branch line of the S&DR for freight, which ran to a coal depot closer to Yarm, again on the north side of the river in the area around the Cleveland Bay public house. The association of the town with the railway is not forgotten; there is a plaque on the wall of the George and Dragon pub in the High Street that records a meeting held there – although it does suggest that this was the centre of the development of the railway scheme when it was just one of many meetings. But this is not to downplay the part played by the people of Yarm as they had an interest in bringing the railway to the town in the hope of regaining some of the trade that had been lost.

Stockton-On-Tees

In 1754, Mr R. Angerstein, a member of a family of Swedish ironmasters, travelled through England to investigate the country's industry. He commented on Stockton:

> From all the new houses and very broad main street, it is clear that the town has been laid out in recent times and continues to grow. This is partly because of copious supply of lead from the upper part of Yorkshire and also because of the exceptionally rich copper mine discovered thirteen years or so ago at Middleton Tyas, 12 miles from here. Shipping is the principal activity here apart from sugar refining set up by Mr Sutton & Co. and some looms for sail cloth.

Stockton was becoming a commercial centre, with the lead from the mines and smelters in Swaledale and agricultural produce from the area being traded and shipped to Europe and London from the port. Flax from Riga was brought into the port to be used to make ships' sails and linen, as was hemp for making ships' ropes and timber from the Baltic for the ship and house builders. The coastal trade also brought goods into Stockton; coal and salt was shipped from Newcastle and Blyth while London provided tobacco, tea, sugar and hops.

While Stockton's port was growing, others had also experienced expansion. These included Newcastle, with its coal shipments, and Hull, which had the advantage of being connected to the country behind it by canals and navigable waterways. Nevertheless, Stockton was becoming a prosperous town and this had allowed the old thatched cottages that dominated the town to be replaced with stone and brick buildings. One area, behind the parish church, reflected the wealth that had been generated; this was Paradise Row, with fine houses facing a square that was set out with gardens. Gloucester House was part of this and still stands in Church Road.

During the eighteenth century, the setting up of turnpike trusts, thus improving the major roads into the town, increased trade. Another boost came in 1769 when a bridge across the Tees was opened; before this the only way across the Tees at Stockton was by a ferry boat.

The increasing trade through Stockton was noted by John Brewster in his book *The Parochial History and Antiquities of Stockton-upon-Tees*, which was published in 1829. He wrote that,

> There are now wagons in almost every direction an easy communication is made with Kendal and other parts of Westmoreland and Cumberland by which means they may be supplied with goods from London in a more expeditious manner than from Lancashire, Whitehaven or any of their own seaports.

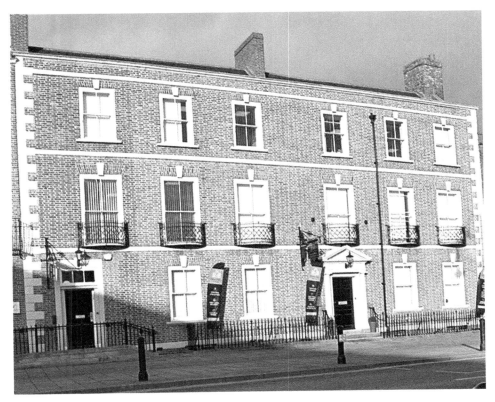

Gloucester House in Stockton.

However, there was still a problem with the port facility. As it was 15 miles from the mouth of the Tees, the meandering river and reliance on tides meant that it could take up to four days to reach Stockton. By the mid-eighteenth century the difficulty in reaching Stockton had encouraged the growth of three facilities further downriver at Portrack, Newport and Cargo Fleet. The Portrack facility saved the 2-mile struggle around the Mandale Loop, while there were warehouses at Cargo Fleet and a granary at Newport. The limitation of the port was highlighted in 1736 by a merchant who noted that a ship had been part loaded with lead at Portrack but 'will take no more until he gets downriver', when more cargo could be loaded.

Something had to be done to improve the access to the port. It seems that in 1769 a trader in Finkle Street had suggested reducing the distance from the sea to Stockton by cutting out the Mandale Loop, but it was not until 1810 that work to shorten the Tees was undertaken. The scheme had taken years to come to fruition and was not easily achieved; difficulty arose when Lord Harwood opposed the plan because land that he owned with a flour mill and warehouse within the Mandale section would become isolated and no longer have access to the river. He was eventually persuaded to take £2,000 in compensation and Parliament approved the work. To pay for the construction work, shares were issued in the newly formed Tees Navigation Company, and to provide a return on this investment a levy was charged on ships using the river.

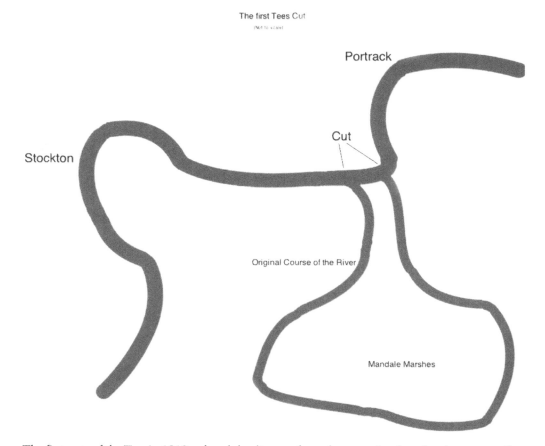

The first Tees Cut
(Not to scale)

Portrack

Cut

Stockton

Original Course of the River

Mandale Marshes

The first cuts of the Tees in 1810 reduced the distance from the sea to Stockton by above two miles.

The town was growing but was still clustered around the High Street, with lanes leading down to the warehouses, boat yards, timber yards, customs house and quays by the river and on the eastern side of the High Street the town was bounded by West Row. The population had increased from 1,820 in 1725 to 3,614 in 1794, but it was during the nineteenth century that the town saw significant expansion, and by 1851 the population had grown to around 10,000. Housing was provided by infilling the yards radiating from the High Street, and then to the west the area around Brunswick and Albion Streets, followed by Commercial, Tees and Union Streets around the north shore. With little regulation coupled with the pressure to provide accommodation for the influx of families, some poor conditions developed that had a serious impact of health. In 1850 a report on public health in the town provides some idea of the environment in the poorer areas. Down by the river at Castlegate there was a 'sewer which opens into the river much above the low water mark'. In Green Dragon Yard there was 'a manure heap under some windows and a surface drain down the yard'.

The growth of the town during the nineteenth century came from the expansion of shipbuilding and the efforts of entrepreneurs who brought new industry. Shipbuilding had been carried out for years in Stockton, and by 1776 there were two adjacent shipyards

at the north shore – one yard was owned by Thomas and Mark Pye, while Thomas Haw built ships next door. Another boat yard, the Castle Moat Yard, was sited at the other end of the town. In the later part of the eighteenth century the shipyards were busy; for example, between 1782 and 1790 the yards launched twenty-four ships. As trade grew the demand for new ships followed and shipbuilding increased as the nineteenth century progressed. In 1805 the tonnage of ships launched at Stockton was 249, and while there were some fluctuations because of downturns and recoveries in the economy, the trend was upwards, and by 1866 the output increased to 9,305 tons. The shipbuilders were supported by other businesses; a ropery had existed for some years and Tennants (owned by the brother of Christopher Tennant) were making sail cloth from imported flax in premises between the junction of Durham Road and Bishopton Lane. Other sail cloth manufacturers were in Portrack Lane and timber yards were situated along the riverside.

The design and construction of ships did not escape the attention of innovators and inventors, and steam power came to supplement and eventually replace sail. The first steamboat built in Stockton was the *English Rose*, which was launched in 1843. Problems arose as owners demanded larger ships and this resulted in heavier hulls, particularly those designed to carry a steam engine, so a lighter material was needed, with iron and later steel providing the solution. Stockton shipbuilders responded and in 1854 the firm of Pearse Lockwood, who operated from their two north shore yards, built their first iron ship, the *Iron Age*. Also in 1854 the *Talpore* was launched from this yard. This substantial steam ship, which was built for the Government for use in India,

A nineteenth-century warehouse at the riverside in Stockton.

was 375 feet long and was designed to carry 3,000 troops. Across the river the Iron Shipbuilding Co. of South Stockton launched its first iron ship, the *Advance*, in the same year. This yard was taken over by Richardson Duck & Co. and by 1862 was employing around 600 people. William Turnbull and Robert Craggs formed a shipbuilding partnership in South Stockton and in 1855 built the *Westminster*, which was said to be the largest wooden vessel built on the Tees at 731 tons and 165 feet long.

One of the early businesses to set up in South Stockton was started by William Smith, who opened a pottery in 1825. Like many businesses, the ownership changed over the years and William Smith was joined by two partners – John Walley, a potter from Staffordshire, and Henry Cowap. It seems that this pottery saw an opportunity to increase sales by using the name of one of the most prestigious potteries in the country. Naturally, Joshua Wedgwood & Sons were not happy with this and acted to stop the Stockton firm using their name; in court the judge ruled that the firm must not use the Wedgwood name in any manner (sometimes Wedgewood was used) and awarded costs to Wedgwood. Pottery continued to be the family business and William Smith's son set up the North Shore Pottery in Stockton in around 1845.

South Stockton (now Thornaby) continued to develop. In 1839 a factory to make glass bottles was being built and one newspaper commented on this, as well as the opening of a

Identifying transfer marks used by Smith's North Shore Pottery. (Preston Park Museum and Grounds)

shipyard and extension of a branch of the railway into the industrial area: 'In consequence of these and other important works no doubt a new town is rising into existence.'

In 1840 a cotton mill was built in South Stockton and by 1844 it was offered for sale by auction. It was described as extending over five floors, which were 100 feet by 50 feet, with machinery that was powered by two steam engines. By 1860 this had been taken over by the expanding Head Wrightson business.

One of the most significant developments in the fortunes of Stockton came in 1825, when the Stockton & Darlington Railway was opened. The shipping of coal was not considered during the planning stages of the railway; indeed, the promoters had accepted a restriction in the haulage charges that could be levied on any coal to be shipped from Stockton. This had been imposed by the coal interests around the Tyne who wanted to protect their business. However, this reduced price worked to the S&DR's advantage and in October 1825 an order for coal to be shipped to Holland was received. In January 1826 the first coal staith was built on the riverside to ease the loading of coal onto ships. To the end of June 1827, there were 18,588 tons of coal recorded as exported; in the next year, this had risen to 52,290 tons.

The unexpected growth in exports prompted the directors of the S&DR to consider a port facility closer to the mouth of the Tees. Despite the improvements that had been

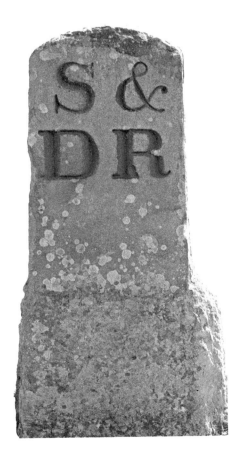

A boundary marker stone from the Stockton & Darlington Railway.

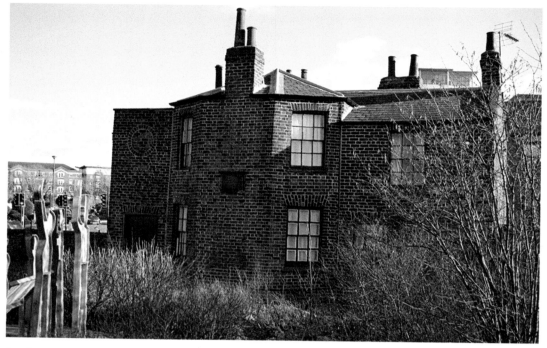

Stockton & Darlington Railway weigh house.

made by the opening of the cut, Stockton was not able to handle the growing shipments of coal, with ships only being able to leave loaded with 100 tons and barges having to follow them to deeper water to load more coal. The S&DR directors looked at two routes for new lines to serve a new facility further down the river – one to Haverton Hill and another to Middlesbrough. They selected the Middlesbrough route as it was the cheapest option, and so began the story of Middlesbrough.

The potential damage to Stockton's prosperity that would come from the S&DR's move was seen as a betrayal by some of the founders and members of the Management Committee of the S&DR, who summarily resigned. Even the name chosen for the new venture – Port Darlington – agitated Stocktonians. The Tees Navigation Co. also saw the potential for a reduction in income if the shipping through Stockton was curtailed. Christopher Tennant had championed the 'northern route' from the coalfields to Stockton some years earlier and it had not been forgotten. Tennant acted to preserve the position of Stockton and to fight the dominance of the S&DR, promoting a Bill for the Clarence Railway, which would go from Haverton Hill to a junction with the S&DR at Simpasture (near Aycliffe). At the same time the Tees Navigation Co. presented a Bill to shorten the Tees with another cut above Newport. Both Bills were passed, with the second Tees cut being opened in 1831 and the Clarence Railway completed in 1833.

The Clarence Railway used the S&DR track from Shildon to Simpasture and this gave S&DR officials opportunity to use this to their advantage. Things were made difficult for the Clarence Railway, with tactics being utilised to delay its wagons, such as enforcing a regulation that prohibiting wagons being hauled an hour before or after

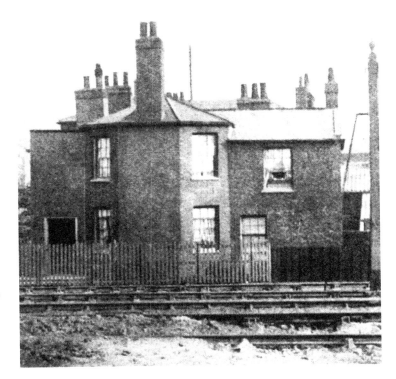

Stockton & Darlington
Railway weigh house
at the time when the
rail line ran past and
continued on to the
riverside at Stockton.

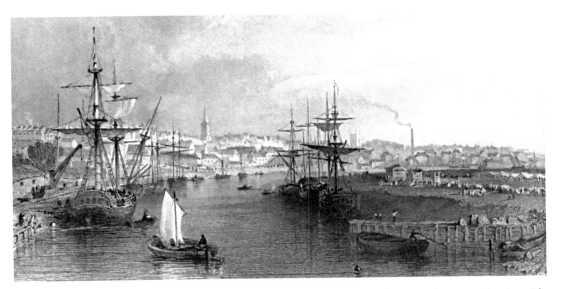

Stockton in the early nineteenth century. Note the horse-drawn railway carriage near the riverside (bottom left of the picture). Across the river horse racing can be seen; this was before South Stockton became industrialised and the event was moved to Billingham. In 1855 racing returned to Stockton at Mandale, within the land that had been surrounded by the Tees until the Tees cut isolated this section of the river. (Preston Park Museum and Grounds)

dusk while this restriction was ignored for other operators. As was noted earlier, there was a reduced charge for transporting coal that was bound for export; however, the Clarence Railway were charged the full price for all coal that was sent over the line. This was challenged by a user of the Clarence line, who was able to show that some of the coal had been shipped to London, but this was not accepted by the S&DR, who argued that they could not know the ultimate destination of the coal when it left their line at Simpasture. In addition, they said, sale to London did not constitute export. The argument ended up in court, where the S&DR's arguments were not accepted and the railway was forced to reduce its rates.

The expansion of the railways and the shipbuilding attracted engineering firms. Around 1839, George Fossick and Thomas Hackworth (Timothy Hackworth's brother) started manufacturing locomotives and rolling stock in buildings close to the place where the Clarence Railway crossed Norton Road. Initially the firm concentrated on the railways and contracted with the Clarence Railway to build locomotives and wagons, but there was an opportunity to take advantage of the trade from shipbuilders and to build marine engines. During the 1860s, when the firm was employing around 700 people, the business was taken over by George Blair, who had been manager for some years and had extended the factory and developed marine engine work. The name was then changed to Blair & Co. Ltd.

Teesdale Iron Works was a foundry business that was started in 1840, and, like Blair's, would see a change of ownership; by 1866 it was operated by Howard and Arthur Head and Thomas Wrightson, and its name was changed to Head Wrightson. The firm would grow through acquisition and amalgamation into a vast engineering business producing castings, bridges, locomotives and viaducts. The engineering skills that were developing allowed the opportunity that was presented by the discovery of the ironstone deposits in the Cleveland Hills to be grasped. Soon there were furnaces on both sides of the river providing employment for hundreds. Holdsworth, Bennington & Byers opened the Portrack Iron Works in 1854 with three blast furnaces. The demand by local shipbuilders for iron plates was met when the Stockton Malleable Works were opened next to the Portrack furnaces in 1862. In 1859 the Thornaby Iron Works was opened by Thomas and William Whitwell; their first furnace was completed by 1861 and stood 69 feet high with a capacity of 10,000 cubic feet. Pickerings Lifts is still based in Stockton but its history can be traced back to the mid-nineteenth century, when Jonathan Pickering started the business to manufacture lifting equipment for the shipyards and iron works.

Stockton cannot be left without recognising another of the inventors of the period. John Walker was an apothecary and by 1827 he was selling friction matches from his shop at 59 High Street, charging 1*s* (5p) for a box of a hundred. This was a breakthrough and a step to replacing the tinder box and the involved process of starting a fire. A note from the period explains:

> The tinder was made of a piece of old rag, which after being partially burnt was placed in a wooden box. Matches [were] made from thin pieces of wood; each end was dipped into brimstone while in a hot state; a pan with a handle being kept for this purpose. A piece of flint and steel were also required, and to produce sparks, sharp blows were struck on the steel with the flint and sparks flying off lit the tinder. A match was then placed against the spark of fire, and light was the result!

1858

RULES & REGULATIONS

TO BE OBSERVED BY THE WORKMEN,

IN THE EMPLOY OF

FOSSICK & HACKWORTH.

1.—The Bell will be rung at Six o'Clock in the Morning, and at Six o'Clock in the Evening, throughout the year, for a day's work; on Saturdays, the day's work will end at Four o'Clock.

2.—The Meal-times allowed are, from Half-past Eight to Nine o'Clock for Breakfast; from One to Two for Dinner; during which period: the first quarter of a day will end at Half-past Eight o'Clock; the second, at Twelve o'Clock; the third, at Half-past Three; and the last at Six o'Clock.

3.—Overtime to be reckoned at the rate of Eight Hours for a day; but no Overtime to be entered, until a whole day of regular time has been worked.

4.—Every Workman to be provided with a Chest or Drawer for his Tools, with Lock and Key.

5.—Any Workman neglecting to write on his Time-board, with his time, the name of the Article or Articles he has been working at during the day, and what Engine or other Machinery they are for, to be fined 1s.

6.—Any Workman who does not return his Time-board to the office, when done work, and on the Wednesday Evening previous to the pay not later than Half-past Ten o'Clock, should he work to that time, with his full time written thereon, to be fined 1s.

7.—Any Workman either putting into the office, or taking out of the Store-house, any other board than his own, to be fined, for each board, 1s.

8.—Any Workman leaving his job, without screwing down his gas, or on quitting work, leaving his candle burning, or neglecting to shut his gas-cock, to be fined 1s.

9.—Any Workman enlarging, or in any way altering or damaging his gas burner, to be fined 1s.

10.—Any Workman leaving his work, without giving notice to his Foreman, to be fined 1s.

11.—Any Workman opening the drawer of another, or taking his Tools without leave, to be fined 1s.

12.—Any Workman taking tools from a Lathe or other piece of Machinery, to be fined 1s.

13.—Any Workman not returning taps or dies, or any general Tool, to the person who has the charge of them, as soon as he has done with them, to be fined 1s.

14.—Any Workman taking Strangers into the Manufactory, without leave, or talking to such as may go in, to be fined 1s.

15.—Any Workman coming to, or returning from work, who comes in or goes out at any door, other than that adjoining the office, to be fined 1s.

16.—Any Workman interfering with, deranging or injuring, any Machinery or Tools, to pay the cost of repairing the damage.

17.—Any Workman washing himself, putting on his coat, or making any other preparations for leaving work, before the bell rings, to be fined 1s.

18.—Any Workman taking any kind of Wood, Chips, or Shavings, out of the Works, to be fined 1s.

19.—Any Workman creating tumults or noise in the Manufactory, at any time, to be fined 1s.

20.—Any Workman Smoking, during working hours, to be fined 1s.

21.—Any Workman using Oil, to clean his hands, or for any other improper purpose, to be fined 1s.

22.—Any Workman giving in more time than he has worked, to be fined 2s. 6d.

23.—Every Workman using the following Tools, either to provide himself with them, or to have them supplied to him by his Employers, and the cost deducted from his wages, viz.:—one pair of Compasses, one pair of Callipers, one two-foot Rule, one Plumb and Line, and one Square.

24.—No Workman to leave the employ, without giving two weeks' notice; and the same to be given by *Fossick and Hackworth*, to any Workman whose services they may cease to require, except in case of misdemeanour.

25.—Any Workman not giving proper notice to the Night Watchman, in respect to starting and leaving off Work, is subject to be Discharged, without the usual notice.

Fossick & Hackworth factory rules. (Reproduced by permission of Durham County Record Office Cp/Shl 16/6)

Plaque from an engine built by Head Wrightson.

Middlesbrough

In August 1828, Joseph Pease sailed along the Tees, past the hamlet of Middlesbrough, and noted in his diary that, 'Imagination here has very ample scope in fancying a coming day when bare fields will be covered with a busy multitude and numerous vessels.' This trip was taken a few months after the construction of a railway from Stockton to Middlesbrough had been approved by Parliament. Middlesbrough was set to become the new base for the transportation of coal from the Tees. The rise of this late starter in the Industrial Revolution was spectacular; in 1801 there were twenty-five people recorded in Middlesbrough, but by 1871 there were 39,563.

The driving of the railway into this isolated spot meant that facilities had to be developed to load and service the colliers and provide housing for those working in the new town. So, in 1829 a group of Quakers – Joseph and Edward Pease, Thomas Richardson (a cousin of Joseph Pease and a bill broker), Henry Birkbeck of Norwich (a banker and another cousin), Frank Gibson of Saffron Walden (a brewer and brother-in-law of Joseph) and Simon Martin (a banker from Norwich) – together formed the Middlesbrough Estate and bought 520 acres of land from William Chilton of Billingham for £30,000. Coal staithes were designed by Timothy Hackworth and plans for the layout of a town of 5,000 people were drawn up by Richard Otley, a surveyor who worked for the Stockton & Darlington

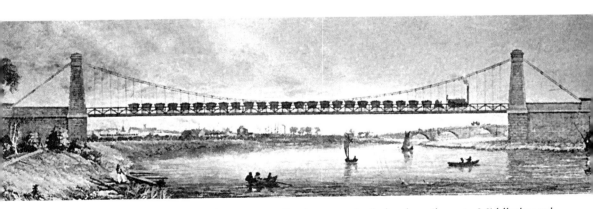

The suspension bridge across the Tees near Stockton was built for the railway to Middlesbrough. It was a disaster and swayed when loaded wagons travelled across it. Drivers would set the locomotive to a slow speed then step down from the engine and wait until it was safely on the other side of the bridge before crossing and catching up with the engine.

Railway. The plan showed a community radiating from a central square with four main roads – North, South, East and West Streets.

The land allocated for housing was divided for sale in plots, and the first house was built by George Chapman in April 1830; Chapman bought several plots to develop, as did Henry Pease and Richard Otley. The idea that the planned layout would provide pleasant houses with gardens was eventually disregarded and more and more houses were squeezed into the plots. Even some of Richard Otley's parcels of land were allowed to become crowded, with back-to-back housing in some parts of Cross and Mason Street.

Plan of Middlesbrough Estate. (Teesside Archives)

An early view of a developing Middlesbrough.

The original area of Middlesbrough Estate. All housing has now gone and it is mainly grassed.

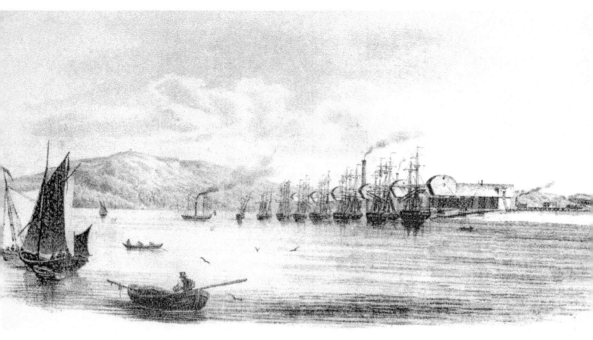

Middlesbrough coal staithes, *c*. 1840.

The export of coal grew beyond all expectations. In 1826 Joseph Pease justified the railway on the basis of it carrying 10,000 tons of coal each year; this reached 150,000 tons in 1830/31 and 1.25 million by 1840.

Other industries were attracted into the town, some with the aid and encouragement of Joseph Pease, who was no doubt driven by the need to produce income for the Middlesbrough Estate. By 1840 the occupations of those listed in a directory shows an established town with chemists, drapers, shoemakers, bakers, a flour dealer, pawnbroker, tailors, drapers, attorneys and an adequate supply of inns. The trade followed by some reflected the new industries; there was a shipbuilder, sail and mast makers and an earthenware dealer and agent for the Middlesbrough Pottery.

Shipbuilding was started and the first ship, the *Middlesbro*, was launched in 1833. Another first came from the Cleveland Iron Shipyard, run by Messrs Rake, Kimber & Co., when the iron ship the *De Brus* was built.

The Middlesbrough Pottery was set up in 1834 by Richard Otley. The work in the pottery factory was far from any craft-based industry, as there were a number of departments within the factory, each specialising in a part of the process. Flint was prepared in the grinding mill, ready to be used to whiten the pottery, while slip workers prepared the liquid clay to be poured into moulds or throwers would prepare pots on wheels. Placers stacked the pots in the kilns ready for firing. Coal was in plentiful supply to heat the kilns and to fuel the steam engine in the factory. There were jobs that required skills such as mould makers and engravers, who produced designs on copper plate ready to make the transfers that were used to decorate the pots. Transfer painting was introduced in the eighteenth century and was much cheaper than hand

A pottery mixing room.

painting. In the early 1840s Isaac Wilson, a relative of Joseph Pease, joined the Middlesbrough Pottery and by 1843 he had taken over the management of the firm from Richard Otley. Later, along with Edgar Gilkes, who was the manager of the local maintenance facility for the S&DR, Isaac formed the Tees Engine Works of Gilkes, Wilson & Co.

The main trade in these early years was still the shipping of coal, but problems developed that threatened the business. In 1834 coal started to be shipped from Port Clarence, followed a year later by West Hartlepool, where the dock had the benefit of facing the open sea. In addition to this competition, the jetties that were built at Middlesbrough by the Tees Navigation Co. with the intention of managing the river flow and maintaining the depth of water had the opposite effect, and the tides brought sand and sediment that was deposited around the jetties, and so reduced the depth of the water. The practice of only partially loading ships was seen again at the coal staithes, with the loading being completed from barges after the colliers sailed down the river into deeper water. To solve this problem a dock was recommended. William Cubitt, a London-based civil engineer, was invited to make proposals for the dock and he set out plans for a facility with an estimated cost of £70,000. Work was started in 1839. The excavation of the dock was not without incident and a mob of around 400 gathered at the train station to await the arrival of Irish men who were willing to accept low wages, threatening the earnings of those already working on the dock. The Irish men

Middlesbrough Dock.

were attacked and police had to escort them to work. Once the police left the Irish were attacked again and police reinforcements had to be brought in from Stockton to bring order back to the town. The Middlesbrough Dock was opened in 1842, with ten new coal staithes that were fed from wagons that were hauled to the dock along an extension to the railway.

By the late 1840s the amount of coal traded through the Middlesbrough Dock was declining. The rail network was by then sufficiently developed to allow coal to be transported around much of the country and the West Hartlepool dock was continuing to provide significant competition. As a result, the town's future looked uncertain.

However, a period of extraordinary growth started in the 1850s, and to explain this change in fortunes two men need to be introduced. John Vaughan, the son of an iron worker, was born in Worcester in 1799 and by 1832 was manager at Walker Iron Works in Newcastle. Henry Bolckow was born in Germany but moved to Newcastle to work in a corn trading business. In Newcastle the two men met Joseph Pease, who talked to them about the wonderful opportunity that was available in Middlesbrough to set up an iron works. This encouragement worked and in August 1841 their forge was opened in Vulcan Street.

Four years later, to provide the foundry with a much-needed supply of iron, Bolckow and Vaughan built four blast furnaces at Witton Park, located at the end of the S&DR close to the coal mines in South Durham. There was a supply of ironstone in the area but this proved to be inadequate and so another source had to be found. This was brought

The early industrial development of Middlesbrough was around Vulcan Street and this Grade II listed wall survives from those days.

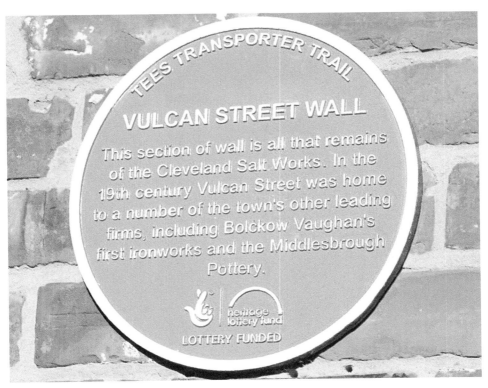

A plaque on Vulcan Street, recording this as a significant area in the growth of Middlesbrough.

from the ironstone mines around Grosmont in the North Yorkshire Moors via ships loaded at Whitby and sailed to Middlesbrough. From Middlesbrough, the ore was then taken by rail to the furnaces at Witton Park. The pig iron produced was then moved back down the line to Middlesbrough. While the hauling of iron to and from Witton Park appears inefficient, it does provide a reminder of the revolution that the railway brought by allowing this to be practical.

Considerable deposits of iron ore were later uncovered in the Eston Hills, and the story of how the deposits were found became part of the folklore of Middlesbrough. The legend around this tells that Vaughan was out shooting rabbits in the Cleveland Hills when he tripped and fell onto a block of ironstone; however, this story rather hides the work and surveys done by John Marley to isolate the ironstone deposits.

Middlesbrough takes off again and the story of the town and the surrounding area takes two main tracks – mining the ironstone and from it the production of iron. Hauling ironstone to the furnaces was soon underway, with the first load being sent to

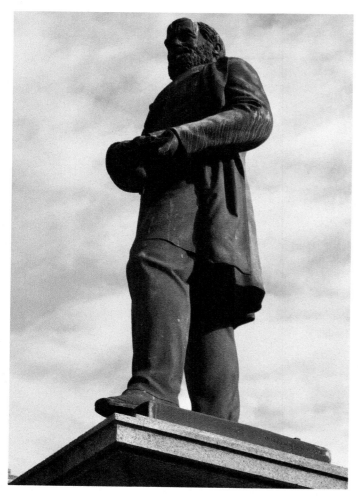

A statue of Henry Bolckow in Middlesbrough.

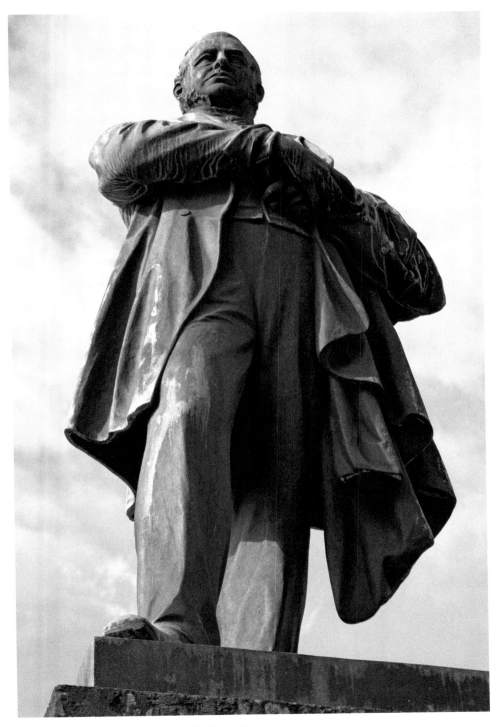

A statue of John Vaughan in Middlesbrough.

Witton Park in September 1850. There were no blast furnaces in Middlesbrough but this changed in 1852 when Bolckow and Vaughan built the Eston Iron Works. More followed and the Tees was soon flowing past belching furnaces from Stockton to South Bank. New firms were attracted to the area; in 1854, Sir Bernard Samuelson built blast furnaces at South Bank and a new settlement was started to provide housing for the workers. Nearby, the Clay Lane Iron Works were set up, and iron works were opened by Swan, Coates & Co. at Cargo Fleet while Cochranes set up furnaces and a foundry at Ormesby. In Middlesbrough, Bolckow and Vaughan extended their engineering operations with blast furnaces in 1856. Isaac Wilson and Edgar Gilkes expanded their operations and opened iron works, Stephenson Jacques & Co. had the Acklam Works and the Linthorpe Works were operated by Lloyd & Co. At Newport, Bernard Samuelson built more furnaces and in the same area were the rolling mills of Fox, Head & Co.

In 1863 a reporter from a Newcastle newspaper was lifted above a blast furnace on the hoist usually used to feed ore into the furnace and he wrote about his experience:

Foundries, river, puddlers' fires were succeeded by vessels, mouths of smelting furnaces and open chimneys shoot up steam, flame and sulphur. Standing above the clouds of

Isaac Wilson.

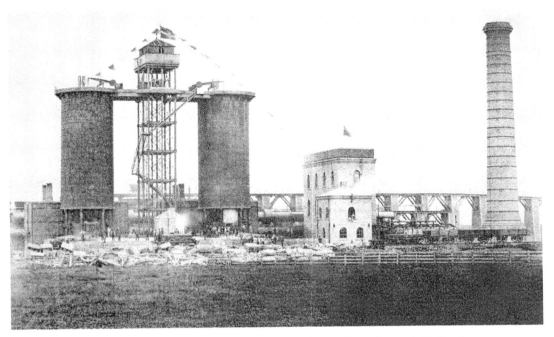

The topping out ceremony at Cargo Fleet Iron Works, *c.* 1860. (Beamish Collection)

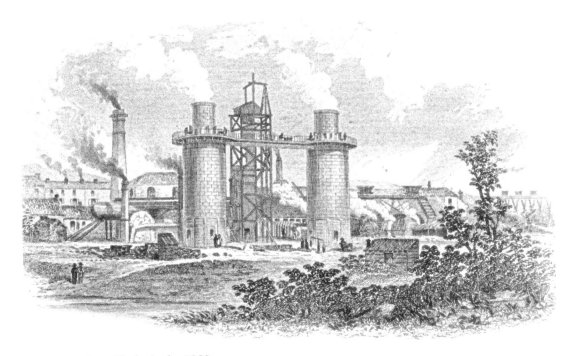

Eston Iron Works in the 1850s.

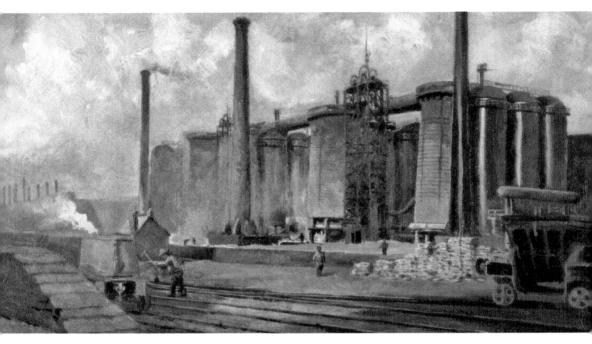

Ayresome Iron Works. (Beamish Collection)

An ingot from Ayresome Iron Works. (Beamish Collection)

smoke you look down in them as they rise, curl and spread themselves. Through the clouds of smoke, made by the wind, you see the 'blooms' – huge masses of molten iron dragged out of the fires, tumbled on the Vulcan hand carts and disappear like so many burning crawling bats. It appears like the very land of Gomorrah.

The technology of iron production did not stand still; the design of blast furnaces evolved and the early ones were replaced by taller and wider structures, allowing more ore to be fired. This provided a great benefit to the Tees-based iron works since the Cleveland rock was relatively low in iron content, containing about 30 per cent. The early furnaces were open topped, which allowed pollution and heat to spill out into the air. The tops were soon closed and the temperature was increased, and at the same time a considerable reduction in the amount of coke that was being burned was achieved. The visiting reporter made reference to this:

> When iron ore and lime are thrown into the top of the furnace ... [it is] then closed hermetically, preventing the escape of smoke and fume. The smoke and fumes are forced down capacious tubes, and mixing with air below, is converted into flame and made to supply the boilers.

In the year the ironstone was discovered, 4,177 tons were quarried around the hills near Eston. Then, in 1851, a drift mine was forced into the hills. Others followed and by 1870 the mines had produced 830,250 tons.

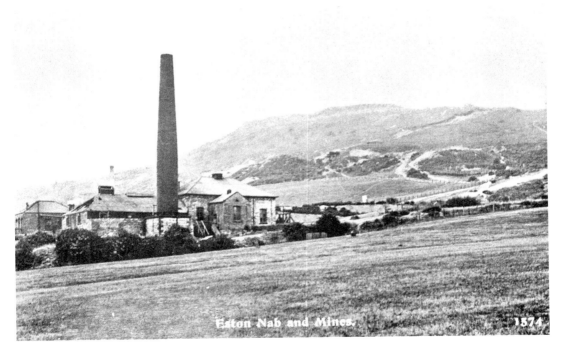

An ironstone mine near Eston.

The entrance to the New Venture Ironstone Mine near Eston.

Single-storey miners' houses at Eston. (Beamish Collection)

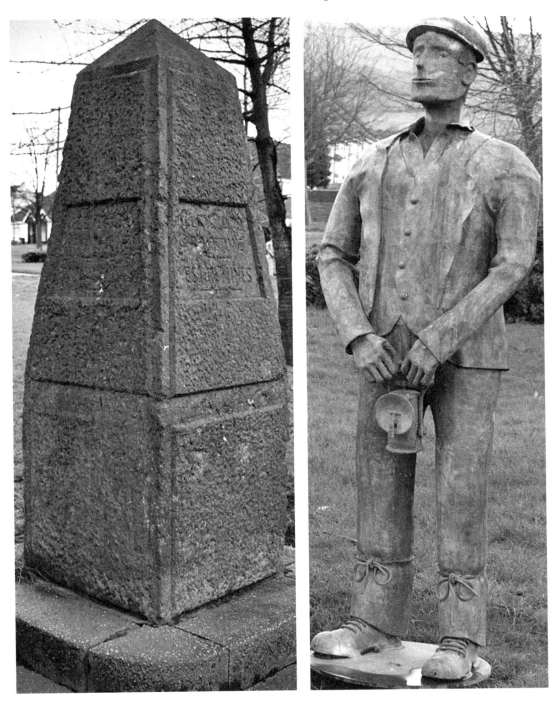

Above left: An ironstone pillar at Eston.

Above right: At Eston, this figure of an ironstone miner is another reminder of the town's heritage.

The little farming hamlet of Eston attracted workers looking for accommodation. The village expanded and a new settlement was started at the edge of the village known as California. Eston was the home of the new Gold Rush!

Bolckow and Vaughan looked to open more mines and approached William Ward Jackson, who owned land at Normanby. However, Jackson wanted to see blast furnaces opened on the northern banks of the Tees and made that a condition of leasing the mining rights. Bolckow and Vaughan did not want to undertake this development and so William refused to deal with them.

William Ward Jackson was the brother of Ralph Ward Jackson, who was instrumental in the development of the railway and docks in Hartlepool. Ralph was, to some extent, carrying on the work of Christopher Tennant, who had originally championed Stockton and the 'northern route' from the coalfield, but was beaten by the S&DR. Tennant had moved to Hartlepool, where he saw an opportunity to develop coal exports through the docks and break the dominance of the S&DR. In 1832 he promoted the Hartlepool Dock & Railway Company. The development continued and the Stockton & Hartlepool Railway connected the two towns when it opened in 1841. The opening of the Clarence Railway had threatened the position of the S&DR and the developments at Hartlepool were a constant threat to the Middlesbrough's role and prosperity. The S&DR had been working on arrangements to take over the Clarence Railway when, in 1851, Ralph Ward Jackson stepped in and amalgamated the Clarence Railway into the Hartlepool Dock Railway. The fortunes of Hartlepool also improved in 1851, when Bell Brothers bought land at Port Clarence and the hoped for industrial development on the north side of the Tees was started. Iron furnaces were built to process ironstone mined on William Ward Jackson's land.

The transporting of ironstone to Port Clarence led to the 'Battle of the Tees', and while fighting broke out on the river, the real battle was about the survival of the Tees as a port against the strong competition from Hartlepool. Ralph Ward Jackson wanted a railway that stretched from the mines in the hills to the south of the river to a jetty on the Tees at Normanby, where a ferry would take the ore across to Bell Brothers' new blast furnaces. The S&DR wanted to protect their interest, however, and proposed a link from their Guisborough & Middlesbrough Railway line to the West Hartlepool Railway at Stockton by means of a swing bridge. Both schemes brought opposition from a number of parties and these are summed up in William Tomlinson's book *North Eastern Railways*:

> Stockton had never forgiven the S&DR for founding Middlesbrough; Middlesbrough opposed the ferry out of loyalty to the S&DR. The Tees Conservancy Commissioners, who regarded the [Hartlepool] ... scheme as a scheme for making West Hartlepool the port of the district, opposed both schemes on the ground that they would interfere with the navigation of the river.

Both schemes were rejected in 1858. Ward Jackson did not give up, however, and tried again in 1860 to have the line approved. This time, the objections were overcome and work went ahead on the jetty at Normanby. The Tees Commissioners reminded Jackson that work could not be undertaken on the river bed without their approval and they took legal action requesting an injunction to prevent work on the jetty, though this was not granted and Jackson continued to build. However, the Commissioners were not

willing to give up their control of activity on the river, and surrounded the jetty site with barges to prevent further work. Jackson was not so easily stopped and he brought two steam tugs along the river with men tasked to remove the barges. The Commissioners' engineer heard of this and responded by loading a boat with men to swell the numbers of those who were already guarding the barges. A game of cat and mouse started, with the barges going to and fro as Jackson's men removed them and the Commissioners' men brought them back. Scuffles broke out and one report suggests that fighting broke out, with men from the two sides battling in the water and on the muddy river bank.

During the day Jackson somehow managed to buy some of the barges, probably by paying an inflated price, and reversed their role, using them to protect his work. Then, in the dead of night, the Commissioners' tug reappeared and set about pulling out the support piles for the jetty that had been driven into the river bed. Jackson's men were waiting, and more fighting broke out. One man was injured when a boat hook was swung at him and eventually the tug left under a hail of stones and iron slag. The North Riding police intervened and reminded the businessmen behind the incidents of their position and warned of the consequences if work was not allowed to continue peacefully.

A little later a scandal surrounding the activities of Ralph Ward Jackson hit the Hartlepool Dock & Railway Company. Jackson had been a leading figure in the development of Hartlepool and he used the railway company to help the town prosper, but his dealings had been beyond those he was authorised to undertake, including borrowing £2 million to purchase collieries and ships. As a result, Jackson was forced to resign.

The Tees at Middlesbrough. (Beamish Collection)

Above and overleaf: Brickworks sprang up throughout the area.

Despite the challenges, industry continued to flourish along the Tees. Another major milestone was achieved when the production of steel – a stronger material than iron – was introduced. The invention of the Bessemer Converter allowed the economic production of steel, but the process required ore with a low phosphorous content, and this ruled out the use of the local ore, which was rich in phosphorous. Bolckow and Vaughan started to import suitable ore from Spain but, thanks to the efforts of Sydney Thomas and Percy Gilchrist, a way was found to use ore from the hills south of the Tees and the revolution continued.

Banking and Finance

Commercial practices had to react to cater for the growing and more sophisticated business activity and to provide a conduit for funds to flow into new undertakings. The partnership was the most common and accepted manner of operating a business. Partners were responsible for all debts and it was the perceived wisdom that this brought honest people to businesses who operated their firm properly to develop trust and a good reputation. Moreover, the potential consequences of personal liability for business debts ensured care and prudence. A joint stock company, where there were a number of shareholders and the shares could be bought and sold, required authority from Parliament before it could be operated legally. This was a requirement of the Bubble Act of 1720, which was introduced to prevent speculation in companies and made the 'act of or presuming to act as a corporate body, the raising or pretending to raise transferable stock without … authority of an Act of Parliament or by Charter from the Crown' illegal.

Promoters of turnpike roads, canals and railways would seek Parliamentary approval because they needed to raise considerable funding, usually beyond the means of a small group acting in partnership.

Despite these requirements and restrictions, some companies were formed without obtaining the necessary permission and in 1802 two judges pronounced that such companies could not use the law to settle any disputes. The existence of companies that were held to be outside of the law led to fears that fraudsters could offer shares in bogus companies, with those who lost money having no redress. Charles Dickens saw the danger and he introduced the United Metropolitan Hot Muffin & Crumpet Making & Punctual Delivery Company in *Nicholas Nickleby*. In a conversation between two of the promoters of this company, which was to have capital of £5 million in shares of £10, we learn their intent: 'Why the very name will get the shares up to a premium in ten days. When they are you know what to do with them and how to back out at the right time'.

The Bubble Act was repealed in 1825 but it took until 1855/6 for limited liability, where investors were only liable for the cost of the shares they had purchased to be extended to all companies (Parliamentary approval had been given to limit liability to shareholders in such ventures as railways).

Banking developed through the years of industrialisation. The Bank of England was formed in 1694 and its main purpose was to raise a £1.2 million loan for the Government, although it started to issue notes as well. London was the banking centre and there were banks in the city for those who wanted to deposit funds. Of course, this was fine for those based in London, but there was also a need to cater for people in the towns and cities away from the capital. Consequently, local banks emerged to

provide a network of banking services. These banks often developed as an adjunct to a business where tradesmen would be willing to offer a service to a customer or supplier who, rather than having money stored in their homes, would trust the trader to hold some of his funds. The trader, in turn, could use London banks to hold deposits. The London Lead Mining Company (LLC) provides an example of the use of provincial and London banks; banking in the North East for the firm was provided by Ripleys, which was based in Newcastle. Ripleys used Coutts in London while the LLC used Barclays. During the 1820s and 1830s a monthly payment by Ripleys was authorised for the expenditure incurred by the company's superintendent in the North Pennines, and this was funded by transfer between a number of banks. For example, in January 1826 the LLC authorised £4,500 to be paid by Barclays to Coutts for the account of Ripleys in Newcastle for 'the balance of the company's pays in the month'.

The development of banks was also seen in Darlington and Stockton. James Backhouse, the linen manufacturer in Darlington, opened a 'banking shop', which eventually became the main family business. Backhouse's Bank started to issue notes and in 1778 forgeries of their 5 guinea notes started circulating. The forgeries were used in shops to buy small value items and change was given in good coins. The culprit was described as being of suspicious appearance, thirty to forty years old, dressed in brown clothes and with a North Country accent. A £100 reward was offered for information that would lead to his capture or that of the engraver who had copied the plates that were used to print the forgeries. The culprit, John Mathison, was eventually caught and was sentenced to death at his trial at the Old Bailey in May 1779.

Another bank that seems to have its roots in Darlington and Durham was Richardson & Mowbray, with branches in Barnard Castle and Thirsk. The remnants of a guinea note issued by this bank show the partners as Mowbray, Hollingworth, Wetherell, Shields and Boulton, which would suggest it must have been issued after 1806, when these five were the partners. The bank failed in 1815 and Backhouse took over the Darlington premises on High Row, the site of which is now Barclays Bank.

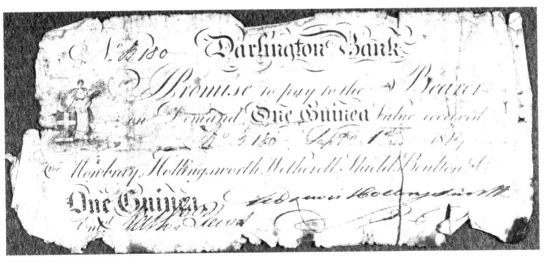

A one guinea note from Darlington Bank. (Beamish Collection)

Bills of exchange could be used to make payment, although the payment date could be in the future. This was done to allow the purchaser of goods time to process them and sell them on and receive income. Of course, the supplier may not want to wait to receive his money and Thomas Richardson, a cousin of Edward Pease, set up a successful business with another Quaker, John Overend, as bill brokers, offering to buy forward-dated bills at a discount and making money by collecting the full amount when payment became due. Thomas was also a shareholder in the Stockton & Darlington Railway and the Middlesbrough Estate and retired to Great Ayton, where he became a generous benefactor.

A number of banks were established in Stockton. The Tees Bank, which opened in 1785, was the victim of a robbery, and the events display an innocence or ineptitude in their procedures. The firm would send cash and notes to Newcastle and Sunderland to settle accounts with banks in those towns. One morning in 1825 a clerk loaded his box of money under the seat of the coach he was to travel in and, as there were no other passengers waiting, he left the box and went to the nearby inn, keeping his eye on the

The bank on High Row, Darlington, which was bought by Backhouse's Bank.

Backhouse's Bank opened this grand building on the site of the original bank in 1866, and this remained as the bank's headquarters until the merger with Barclays in the late nineteenth century.

coach from the window. When he arrived at Sunderland the box was gone – the thief had used the door on the other side of the coach!

The Tees Bank failed in 1826, and since the bank was operated as a partnership, the partners became personally liable for its debts, which forced them into bankruptcy; in order to repay those who had deposited money with the bank, their personal property was sold. As well as the bank, the firm operated a timber yard in Stockton, and the timber stock and yard were advertised for sale by auction, as was the property of Thomas Place, one of the partners. His house at Low Worsall, 'with extensive grounds and cottages', was auctioned, as was the 41-acre house at Norton belonging to another partner, John Hutchinson.

The bank of Skinner, Atty & Holt in Stockton traded as the Commercial Bank and had branches in Darlington, Stokesley, Barnard Castle and Yarm. In 1825, the reaction to the financial crisis that developed when the economy contracted in that year produced fears that banks would fail. In Stockton there was a run on the Commercial Bank; depositors queued outside the bank, all wanting repayment of their money. They were somehow pacified until a coach arrived from London with cash.

Backhouse's Bank was also faced with a demand for cash in 1819; this was not the consequence of any financial crisis, but was orchestrated by Lord Darlington as part of his attempt to undermine the proposed Stockton & Darlington Railway. Jonathan Backhouse was a key supporter of the railway and the Lord targeted the bank by asking his tenants to pay their rent to him in Backhouse notes. When he had accumulated enough, he attempted to make the bank fail by presenting them all at once and demanding gold in payment, as the notes were a promise to pay and should be supported by gold. Much of Backhouses' reserves were with their London bankers; the gold had to be brought quickly from London and the story was told that when the coach carrying it was travelling through Croft a wheel fell off. Rather than wait for the coach to be repaired, the gold was positioned to balance the coach and it carried on with

'Balancing the cash' – the dash to Backhouse's Bank in Darlington.

three wheels. Lord Darlington's plot failed and Backhouse reputedly told Darlington's agent that if his 'master wanted to sell Raby it would be paid for with the same metal'.

The country banks were the source of some funding, often on a short-term basis, but as we have seen not all were financially secure. As a result, there was a need for stronger and larger banks that could channel long-term finances for industry. In Middlesbrough a branch of the London & Northern Joint Stock Bank was established. This had a strong capital base when it was formed in 1862 with capital of £1 million made up of shares of £100 each, but those applying for shares were only asked to pay £20 per share, leaving the remaining £80 as an assurance that additional funds could be called on if needed, thus giving customers confidence in the stability of the bank. This bank was taken over by the Midland Bank in 1864 and amalgamations like this brought the main banking groups, such as Lloyds, Martins and Barclays, to the country.

Acknowledgements

I must record my thanks to those who have helped with my research, in particular at the Centre for Local Studies in Darlington Library, the Teesside Archives, North Yorkshire Record Office, Durham Country Record Office, the Fitzhugh Library in Middleton in Teesdale, Beamish Museum, the North of England Institute of Mining and Mechanical Engineers and Preston Park Museum.